SHARP FOCUS
WATERCOLOR
PAINTING

Mrs. Virginia A. Schafer
P.O. Box 404
Hopland, CA. 95449-0404

SHARP FOCUS WATERCOLOR PAINTING

Techniques for Hot-Pressed Surfaces

By Georg Shook and Gary Witt

WATSON-GUPTILL PUBLICATIONS/NEW YORK

First published in 1981 by Watson-Guptill Publications,
a division of BPI Communications, Inc.,
1515 Broadway, New York, N.Y. 10036

Library of Congress Cataloging-in-Publication Data
Shook, Georg, 1934–
 Sharp focus watercolor painting.
 Includes index.
 1. Watercolor painting—Technique. I. Witt,
Gary, 1945– joint author. II. Title.
ND2422.S54 1981 751.42′2 80-25277
ISBN 0-8230-4795-4 (pbk.)

Printed in Japan

Paperback Edition
First Printing 1993

1 2 3 4 5 6 7 / 99 98 97 96 95 94 93

To Jeremy, Joanna, Brandi, and Codi

ACKNOWLEDGMENTS

I am grateful to those who helped make this book possible, especially:

Margaret Witt, who assisted with her time, energy, and moral support.

Marsha Melnick, Dorothy Spencer, and Lydia Chen of Watson-Guptill Publications, for their support, advice, and patience.

Jay Anning, for the design of this book.

All those persons who own the paintings reproduced in this book.

Dave Pottenger of the Strathmore Paper Company, who first introduced the Strathmore Hi Plate surface to me.

Fred Gould of the Strathmore Paper Company, who, in response to the technical problems which arose during the development of this book, helped me design the Georg Shook wash brush.

Gary Witt, who went beyond the call of duty by not only writing but also editing, typing, and photographing materials for this book, as well as offering constant encouragement.

CONTENTS

FOREWORD

Georg Shook is without doubt a master technician in watercolor. His sharp focus realism on the hot-pressed board shows dazzling control, and this book demonstrates the techniques which Georg has taught himself in order to gain that control. But technique without purpose is like being all dressed up with no place to go.

Georg has places to go and has already been to many—giving twenty workshops a year, visiting galleries where his work is exhibited, and attending meetings of artistic organizations of which he is either an officer or member, often to pick up another award. His purpose is a single one: to paint the South which he knows and loves so well. He understands the South—its dignity, its nobility, and its pride—and he works hard to capture these qualities in paintings that other people can understand, too.

He has referred to his work as "landscape portraiture," and he is right. Like a good portrait, his work is detailed, solid, and totally convincing. His realism describes the surface, but his art penetrates that surface and turns description into drama. He loves to paint light, and he turns fleeting moments into essences. He loves to describe the visual facts of the Delta realistically, but in his art these facts bloom into symbols, memories, and shared secrets.

Much of this has to do with what Georg paints, and much of it has to do with the way he paints, as you will see. But much of his art also has to do with the way he is, and I am proud to have coauthored this book with him.

Gary Witt

INTRODUCTION

The three elements required for producing any watercolor painting are brushes, paints, and a painting surface. For trained watercolorists, "surface" has usually meant papers of varying roughness and absorbency —papers whose textures greatly contribute to the coarse look typical of a finished watercolor painting.

There is, however, another, less popular surface available called the hot-pressed surface. Although it is not new to the field, it is not a commonly used watercolor paper. Many who do attempt to use it, I'm afraid, are frightened by its unfamiliar qualities and therefore fail to work through the seeming disadvantages and limitations to get to the very real rewards.

My purpose in writing this book is to help overcome this frustration by giving insight and solutions to the problems of painting on a smooth surface. The exercises and demonstrations are directed toward this end, and I hope I can also show that controlled realism is more than precise technique—it is the embodiment of the abstract design qualities which are the expressive strength of all good painting.

My experience has taught me that fine craftsmanship comes only from practice. With practice, one can develop sensitivity, awareness, perseverance, and patience. And while a book cannot substitute for practice, I hope that this book will encourage you to try the hot-pressed surface— or for some, to try it again—and to explore, experiment, and keep painting. The effort, I can assure you, will be worthwhile.

Georg Shook

STUDIO MATERIALS AND EQUIPMENT

There is one simple rule about materials and equipment that artists at all levels of accomplishment should follow: buy the best you can afford, and then take very good care of it. There is really no substitute for fine equipment, and it is better to have one expensive brush than ten cheap ones. The higher-quality brush will respond better and will last practically a lifetime. The same holds true for papers and pigments: try to get the best materials, since they will always repay you by meeting your needs beautifully. Of course, it is not always easy to know just which are the best in materials and equipment, and so I urge my students to be on constant lookout for new information. Reading the latest art magazines, shopping at the better art supply houses, talking to fellow artists—these are all good ways to learn about fine current materials.

Sometimes, however, the right piece of equipment may be hard to find, or it may not even exist. My advice then is to innovate, invent, or otherwise create what you need. You can have great fun just looking for ways to improve your materials and equipment. For example, I spent years searching for just the right surface on which to execute the paintings I had in mind. Likewise, I experimented with various watercolor pigments and brushes before settling on the ones that I currently use. My outdoor water container is an old ammunition box; my portable easel is homemade and fits onto a camera tripod; my indoor palette holds more pigment because I build it from discarded can tops; and my scribing tools are the wooden ends of my brushes, which I sharpen with an X-acto knife. I prefer using these improvised items not because they are cheaper but because they meet my needs more precisely. On the other hand, sometimes you may want to invest extra money to have a certain item built to your design because you can't find what you want in the art supply houses. If you find yourself in such a situation, remember that artists all have one thing in great abundance, and that is imagination. Use it to find your personal answers to that often-asked question, "What equipment do you use?"

STUDIO

I have always loved the Mississippi River. It is the real focal point of Memphis, and I spent a considerable amount of time looking for property along its banks. I finally found an old, abandoned cotton warehouse and, to make a long story short, I now live and work in a completely renovated riverfront loft.

My studio and living area total 1700 square feet (518 m²), and I have a skylight 25 feet (8 m) above my work space. I left the original wooden floors and removed plaster to expose a long wall of the original brick. Since my loft is perched on a bluff above the river, I wanted to have a roof deck and had to design a spiral staircase to get to it. But considering the time I have spent up there, just watching the river, I think the extra effort of having it built was worth it.

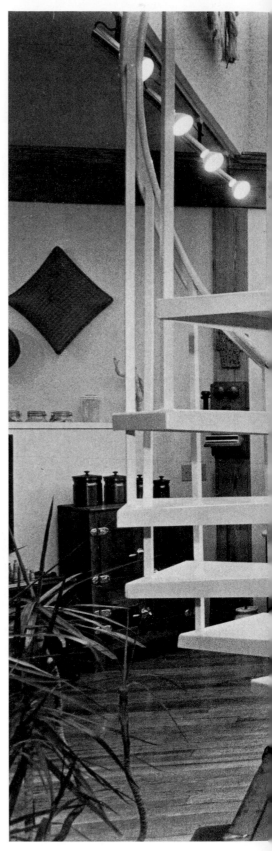

ABOVE: My roof deck overlooks the Mississippi River, and I spend a considerable amount of time there, enjoying the view and painting.
RIGHT: Inside my studio, I do most of my work at my Dietzgen hydraulic drawing board.

PAPER

All the demonstrations in this book are on Strathmore Hi Plate Illustration Board, a hot-pressed surface usually used for commercial art. Its use as a surface for watercolor painting is fairly new and infrequent, but it is perfect for me since it allows the painting of controlled realism with watercolor.

My first introduction to hot-pressed surfaces came when I was painting portraits only. I found that the conventional watercolor papers were so absorbent that they did not allow the flexibility needed for removing pigment or lifting highlights. To overcome that problem, I tried working in acrylics for a short while, but I didn't like the heavily pigmented effect. I wanted to paint controlled realism, and, even more, I wanted to preserve the transparency of watercolor. So I began looking for a smooth, nonabsorbent watercolor surface. My first discovery was that applying gesso to a watercolor board made a fairly smooth surface and that sanding the gesso made it even smoother, which allowed for easier removal of pigment. But this was a lot of trouble and was not always successful. Then I found out about very smooth hot-pressed surfaces, called Bristol boards, which were being made for commercial art. This encouraged me to investigate further, and I finally found that several hot-pressed surfaces were available which met my needs.

The extremely smooth surface of hot-pressed papers and boards is created during the last step of the paper-manufacturing process when the paper is compressed under thousands of pounds of pressure by a friction-heated plate. This procedure presses the fibers into a smooth, nonabsorbent surface—a surface so smooth that it truly adds a new dimension to watercolor painting. Colors lie right on the surface of this board and therefore appear to be more brilliant and alive. Also, the surface is forgiving: an entire painting can be completely washed off hot-pressed board.

The real advantage of the hot-pressed surface, however, is that its extreme smoothness allows the artist to create his or her own texture. Unlike absorbent papers, which dicate the texture of the finished painting, hot-pressed surfaces permit the experienced artist to totally manipulate and control the pigment.

I work on three types of hot-pressed surfaces: Strathmore 115 watercolor boards, the Gemini series of hot-pressed watercolor papers, and Strathmore Hi Plate Illustration Board. The 115 board is hot-pressed paper mounted on a heavy board backing, while the paper in the Gemini series is a two-sided paper, available with either absorbent or hot-pressed surfaces and in 140-lb. and 300-lb. weights.

My favorite among the three, however, is the Strathmore Hi Plate Illustration Board. It is the hardest and smoothest of all the surfaces, and painting on it is like painting on white glass. Hi Plate Illustration Board is available in 4-ply and 14-ply weights and comes in two sizes: 240-2, which is 20″ × 30″ (51 × 76 cm), and 240-4, which is 30″ × 40″ (76 × 102 cm). Hi Plate boards have painting surfaces on both sides and can be split between the layers to make two boards, but I prefer to use only one side of the 14-ply board.

It seems safe to say that hot-pressed surfaces have altered the very nature of watercolor painting. They offer the artist the delicacy and transparency of watercolor while granting him or her the flexibility of oil and acrylic painting. They allow the widest possible range of textures, from the fine veil of morning mist to the rough authority of a gnarled tree.

Of course, different techniques are called for when painting on the hot-pressed surface, and extra attention must be given to avoid certain mistakes that are easy to make. For example, by going back over a painted area, you can accidentally lift out the color underneath. Using short, choppy strokes can also lift color from the board. Avoiding these and other pitfalls requires a smooth, deliberate touch which must be learned, but the rewards of using the hot-pressed surface make the learning well worth it.

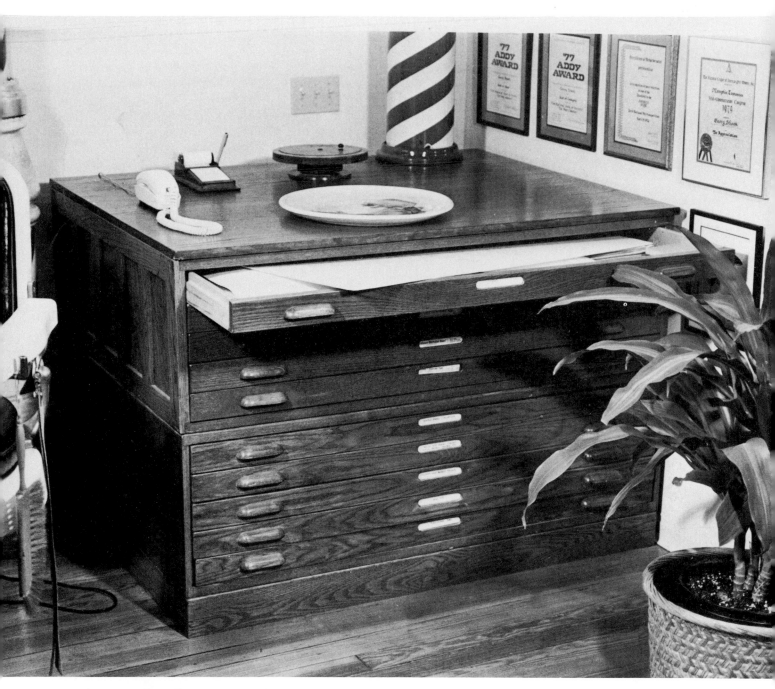

My Strathmore Hi Plate Illustration Boards are stored flat, in this Dietzgen wooden storage cabinet. The cabinet has two tiers, each containing five 36" × 48" (91 × 122 cm) drawers. I also store my paintings here before having them framed or shipped to galleries.

BRUSHES

Brushes come in a very wide variety of types, shapes, grades, and sizes, but choosing the best brushes for your purposes need not be a bewildering experience. I like to keep things simple, and I have found that the following few brushes serve me quite well on the hot-pressed surface.

Chisel-edged brushes. Many of my paintings are done almost totally with ½" (13 mm), ¾" (19 mm), and 1" (25 mm) chisel-edged lettering brushes. These flat, sharp-edged brushes are very versatile and can be used to lay down broad strokes of color or to paint the finest detail merely by adjusting the angle of the brushstroke. I prefer the Strathmore brand, and you will notice throughout this book that the ¾" is my favorite size.

For hot-pressed and Hi Plate surfaces, however, I have always wanted a brush that would offer an extra amount of "snap" against the smooth surface and yet would have enough body to hold plenty of pigment. I feel fortunate to have been able to work with the Strathmore people to design just such a brush. It is called the Georg Shook model

wash brush and is a chisel-edged brush of red sable. The bristles on this brush are only as long as the metal ferrule is wide; its shortness and unique design are what cause the brush to snap back into place after each stroke.

Pointed red sable brushes. These round brushes are excellent for detail work and for applying highly thinned pigments. I use the Strathmore Kolinsky brush; it is made of the finest red sable hair available, gotten from the tail of an animal called a Kolinsky.

Stiff-bristle oil painting brushes and stencil brushes. These round brushes are made from hog bristle and are good for creating textures and for surface color mixing. Because these techniques are very rough on a brush, mine don't last very long and so I buy the more inexpensive models.

Dagger stripers. These brushes were originally used by the automotive industry to paint stripes on cars and are good in all sizes for delineating fine details, especially on trees. Made from squirrel or other soft hair, dagger stripers come to very delicate points when loaded with paint.

As I said before, I seldom use any but these four types of brushes. I try to buy brushes with wooden handles, either coated or natural, because painted handles tend to chip and peel after a while. And I try to take very good care of them. Brushes should be cleaned often by working up a lather of mild hand soap in the palm of your hand and then dragging the heel of the brush back and forth across your palm while running lukewarm water over the bristles. The bristles should be pulled back to their original form and the brush laid flat to dry. When washing stiff-bristled brushes, it is important to remove all the pigment from the heel of the brush. Paint tends to accumulate between these bristles, since they're spread across the base, and good cleaning will help the brush retain its shape longer.

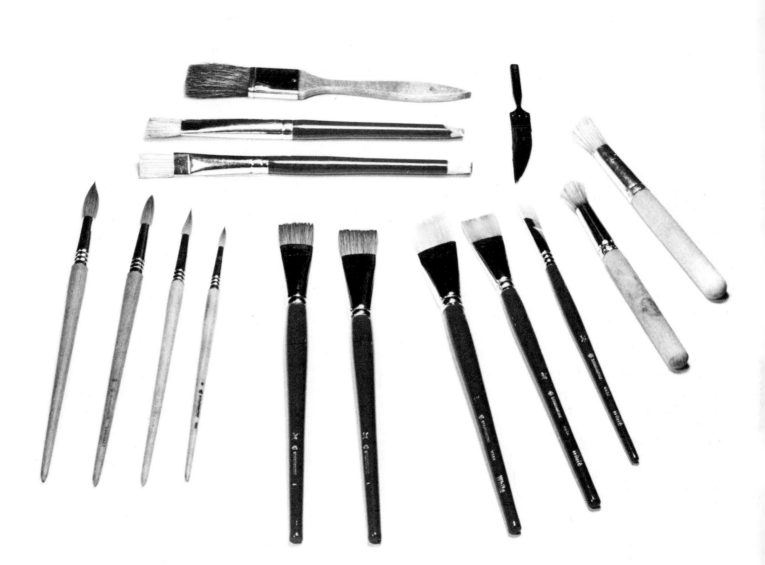

ABOVE: My typical assortment of brushes includes, from left to right, pointed red sables, chisel-edged brushes, and stiff-bristle stencil brushes. At the top are three more stiff-bristle brushes; the small pointed brush is a dagger striper.

LEFT: I had this brush box made to transport my brushes without damaging them, especially since I travel to so many workshops. The box folds to 6″ × 13″ (15 × 33 cm) and is divided to hold a complete set of brushes, as well as erasers, razor blades, pencils, and the like. The springs hold the brushes down tight, and I find the box handy for both indoor and outdoor use.

PAINTS

Although I have fifteen colors in my palette, I usually complete a painting using only three to five colors and various combinations of them. I favor the earth colors because they are especially appropriate for painting landscapes. Also, an advantage to painting with earth colors is that most of the pigment particles lie on the hot-pressed surface and can be lifted out easily.

Since the pigments do lie right on the surface of hot-pressed paper or board, they should be diluted less than on more absorbent papers. If a wash is diluted too much and applied to such a smooth surface, it will float all over the board, losing its color density in the process. A more concentrated pigment will give the control needed on hot-pressed surfaces.

I use Winsor & Newton or Le Franc and Bourgeois pigments. Of course, there are a number of other manufacturers of watercolor pigments, and my advice is to buy the best pigments you can afford. Although watercolor paints come in cakes, pans, and tubes, I use only tubes, and I strongly recommend them. They give quicker solubility and contain more gum arabic, which causes the paint to adhere better to the hot-pressed surface.

The following are the colors in my palette.

Winsor blue makes a good combination with burnt umber for painting shadow and detail. I use Winsor blue mostly for skies, often floated in with Davy's gray. Note, however, that Winsor blue is a staining color and cannot be lifted out easily.

Prussian blue helps to stabilize Van Dyke brown, and when mixed with Van Dyke brown it creates deep shadows. Prussian blue is not as staining as Winsor blue, so it is easier to lift from hot-pressed surfaces.

Van Dyke brown is the only fugitive color I use. (*Fugitive* means that the color is not totally predictable.) It can be stabilized by mixing with Prussian blue, and this is a very good combination for painting shadows and detail. The proportions of the two can be altered to achieve a range of tones from warm to cool.

Davy's gray is prepared from a special variety of slate and gives a pure and translucent effect. The color dries quickly, and it has a tendency to oxidize on the surface, which often adds an interesting dimension to sky, wood, and metal. Since Davy's gray dries so quickly on the palette, it should not be put out until ready to use.

Olive green is a mixture of raw sienna and Winsor green. It is the only tube green I use, because it is not a stain or dye like the other greens. Sap, Hooker's, or Winsor green penetrate even the hot-pressed surface and cannot be easily lifted, but olive green can. To get other greens I mix cadmium yellow and any of the blues—sometimes adding a third color for brilliance and density.

Burnt sienna gives a warm tone to wood, rusty metal, or other weathered objects. Burnt sienna can be mixed with cerulean blue in various combinations from warm to cool to paint light shadows.

Raw sienna is a native earth which is close to yellow ochre in color. It especially good for painting winter grass, weeds, autumn foliage, and marsh grass.

Burnt umber is created by heating raw umber to high temperatures. When mixed equally with Winsor blue, burnt umber is very good for depicting shadows and fine details.

Yellow ochre can be used for toning a late afternoon painting. When mixed with burnt sienna and Winsor blue, yellow ochre makes a beautiful gray.

Cadmium red is a color I like to use primarily for creating skin tones. It can also be mixed with yellow ochre, raw sienna, and cadmium yellow to paint fall foliage. It is good for warming wooden facades as well.

Cadmium yellow is one of the most flexible yellows. It can be taken to light lemon by diluting or all the way to orange by adding red.

Cerulean blue is good for painting shadows of people and can be mixed with burnt sienna to paint light, transparent shadows.

Ultramarine blue was formerly called French ultramarine blue and is the choicest extract of lapis lazuli. I mix it with olive green to paint shadows in grass. I also use it to pull cool shadows across weathered wood and to create shadows on tree branches.

Raw umber is an earth tone and is good for depicting soil, such as a trodden path or barren ground. It also works well as a wood tone. Raw umber can be mixed with olive green to paint winter grass or patches of sparse grass.

Warm sepia is an intimate mixture of burnt sienna and lamp black. I use it to achieve the somber tones of winter grass or to create wood tones on aged subjects such as gnarled trees.

When I want white in a painting, I generally use the white of the board, either by lifting or masking. The only time I will use opaque white is when I flick snow onto a landscape scene. Likewise, I do not use black from the tube because it deadens any color that is mixed with it. I can get a total black by mixing various colors such as Prussian blue, Van Dyke brown or cadmium red, ultramarine blue, and burnt umber, or others. These combinations create a black that has life to it and does not deaden the painting.

Although the colors above are the ones I prefer, there are many others that work well on the hot-pressed surface.

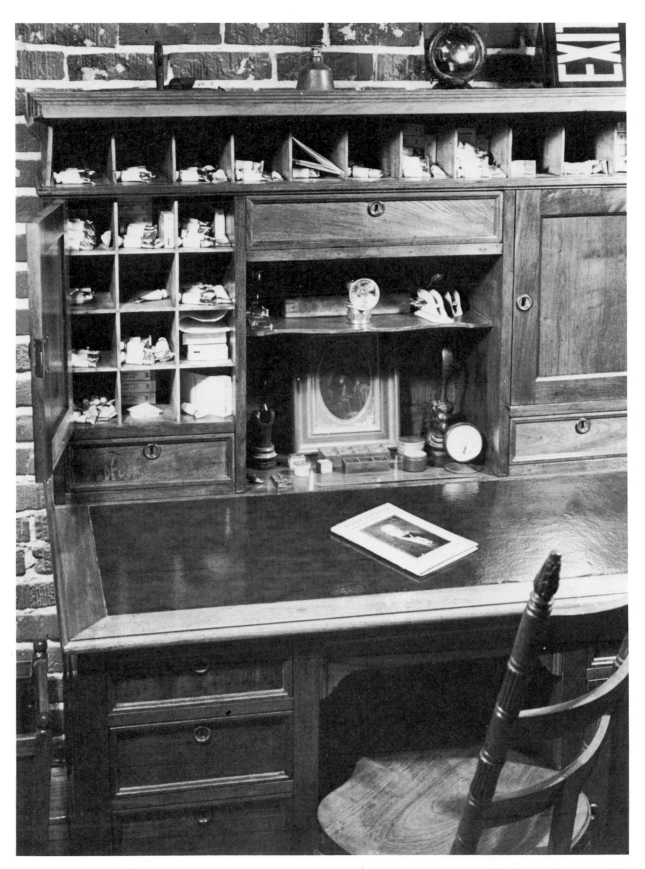

I store my paints in an old plantation desk, which is a useful piece of furniture in a large studio. The top portion of the desk is divided into 23 pigeonhole compartments, each of which has space for several boxes of no. 5 tubes, which is the size tube that I like to buy. The other drawers in the desk are used to store records, photographs, and other reference material.

EASELS

Since pigment tends to lie on the surface of hot-pressed board, I prefer to lay the board flat when I paint. This method, of course, has influenced my choice of easels.

My main easel is a Dietzgen hydraulic drawing board, 48″ × 60″ (122 × 152 cm). This easel has proved to be almost perfect for my particular needs. By pressing a foot pedal, I can adjust the height of the board, and by flipping a lever, I can spin the board around to work a different area of the painting. I can also tilt the surface of this easel to any angle, a feature which comes in handy when I'm working in graduated wash or flat wash.

I also use an upright oil painting easel for heavy pigment painting, such as in portraits or detailed studies. Mine has an electrically operated foot pedal, which allows me to raise or lower the painting itself. This is the first motorized easel I know of, and it was designed in California by Tolegian. It has proved to be a very versatile and sturdy piece of equipment.

The third easel, which I use mostly outdoors, is a Wilkins-Simpson folding easel. I need a small, lightweight easel that can be carried on location for spot painting and preliminary studies, and this easel gives me that and more. It is a self-contained unit that carries my pigments, brushes, and other equipment and unfolds to a full easel on a tripod of adjustable legs. The easel has a side shelf where I can put all my equipment right at my fingertips, and I can adjust it to hold my board fully vertical, tilted, or flat. This feature is a must if you plan to work outdoors on hot-pressed surfaces.

LEFT: This is an Anco easel, an outdoor easel with fully adjustable legs. It has a back support for your drawing or painting, but I use a plywood board to back my illustration board surfaces. Another attractive feature of the Anco easel is that it is inexpensive.

BELOW: I often found myself needing a very lightweight portable easel, and so I designed this one of my own. I had a machine shop drill threads into a metal plate, which I attached to the underside of a drawing board. These threads fit a photography tripod, enabling me to screw the board onto any camera tripod for a neat little outdoor piece of equipment.

LEFT: The Wilkins-Simpson outdoor easel is beautifully designed: the folding legs are adjustable from sitting to standing position, the drawing board itself tilts from fully horizontal to fully vertical, and there is space beneath the board to place your water container and palette. What's more, the easel becomes a suitcase when folded, suitable for carrying your painting gear and supplies. Clip your drawing or painting board to the outside of the unit and you have a fully contained, fully portable system.

PALETTES

When the John Pike watercolor palette first came out, I bought one, mainly for use on location or when giving a workshop. It is a plastic palette with 20 compartments set around a smooth center area. The palette has a snap-on lid, and when I store it, I usually keep a wet sponge inside the closed box to keep the pigments moist. I find this palette so handy, though, that I use it even in the studio.

Another palette which I still use occasionally in the studio is one that I made myself by using an enamel butcher's tray and gluing the tops of spray cans along one edge and side. I usually squeeze a full tube of pigment into each cap, especially when I'm doing a very large painting.

Try leaving your palettes out overnight when working indoors. Leaving the paints exposed seems to make them more pliable and resilient and thus more adherent to the surface of the board. This is especially important when working on hot-pressed surfaces, since they are so smooth that they lack the "grip" of a rougher watercolor surface. You might want to have a spray mister handy to keep the pigments moist—this extends the tactile nature of the paints. It's best not to let the paints dry out completely, but if they do dry out, they can be rewet.

Here is my John Pike palette with an assortment of sponges that I use for creating texture.

SPONGES

Sponges are good for applying paint by dripping or dabbing, for lifting out pigment, and for creating various textures and patterns through imprinting. I use only synthetic sponges because natural sponges tend to disintegrate when left moist. Synthetic sponges also seem to have a certain amount of "bounce," or resistance, when they are used to apply pigment to the surface. Another advantage to using synthetic sponges is that they come in a variety of textures and patterns, giving me a ready-made choice of imprinting designs.

WATER CONTAINERS

I used to find that I never had clean water handy when I needed it, and so I designed a special water container and had a friend who is a potter make it for me. It consists of three separate cups of different sizes that were fused together during firing. It is both a beautiful piece of pottery and a useful tool: I always have clear water for lifting an area or laying down a clean wash, and I also have water for moistening or rinsing my brushes.

I copied the idea for my outdoor water container from another friend of mine. It is an old 30-caliber ammunition box with some wire screen folded and fitted into it about two inches below the water line. It not only holds my brushes, but it doubles as a good scrubbing area for cleaning them.

I adapted my unusual outdoor water container from an army surplus ammunition box. Screen wire is shaped to fit inside the box and sits about two inches below the water level. The lid to the ammo box detaches to become a holder for unused brushes, but when the lid is attached, the container is really watertight and can be overturned without spilling. My indoor water container is a beautiful piece of pottery made by a friend.

PENCILS

Pencils come in a full range of standard leads with varying degrees of hardness, from 9H (extra hard) to 6B (extra soft). You will probably find pencils from the middle of the range to be most useful. For my drawings, I use a fairly soft lead—usually a 2B and sometimes as soft as a 4B, when I want the pencil to show through the wash. I use medium soft leads, such as an H or HB, for basic blocking in when I do outdoor sketches. For portrait or detail work, I like to use a Pentel mechanical pencil, which takes a variety of leads.

ERASERS

There are many different types of erasers available, and by trying them, you will find which ones best suit your needs. I use a variety of ordinary kneaded or plastic erasers to correct my drawings, but I make sure to choose erasers that are not so abrasive that they could damage the painting surface. I do use more abrasive erasers, such as an ink eraser or even an electric eraser, when I want to pull highlights from the painting surface. However, this must be done very carefully.

MISCELLANEOUS

All artists have special tools and aids which meet their particular needs. Here are a few that have been especially useful to me.

Paper towels. These are indispensable, since I use them to blot a painting for texture. I prefer Scott towels because they seem to hold up very well whether I use them wet or dry.

Masking tape. It is fairly easy to use a resist on hot-pressed surfaces since the smooth surface releases the masking material readily. I use masking tape, Scotch tape, and Maskoid as a resist, but any tape is fine as long as it peels away from the surface easily. Be sure that the board is completely dry before attempting to remove any resist material.

Hair dryer. A hand-held hair dryer dries a painting or a section of a painting quickly, and the heated air swirls the paint into beautiful atmospheric patterns. It can also be used to "corral" the paint into a particular area. A heat lamp speeds drying time even more and preserves the wash on the hot-pressed surface before it can float out of the desired area.

Slide viewer. Slides are a good reference tool for doing preliminary drawings, but you should be careful not to rely on the slide for color accuracy, since it will usually appear too intense. A viewer should have a fairly large viewing screen and should also have a fan to keep the unit cool. I use a Kindermann viewer with a 6" (15 cm) screen.

Spray mister. A spray mister can help solve one problem faced by the artist who paints on hot-pressed surfaces: when painting a large sky area, for example, it is best not to allow any part of that area to dry until the sky has been completed, and so a spray mister is useful for rewetting this area. And if you get a mister with an adjustable nozzle, you can use the stream to lift pigment from the surface as well.

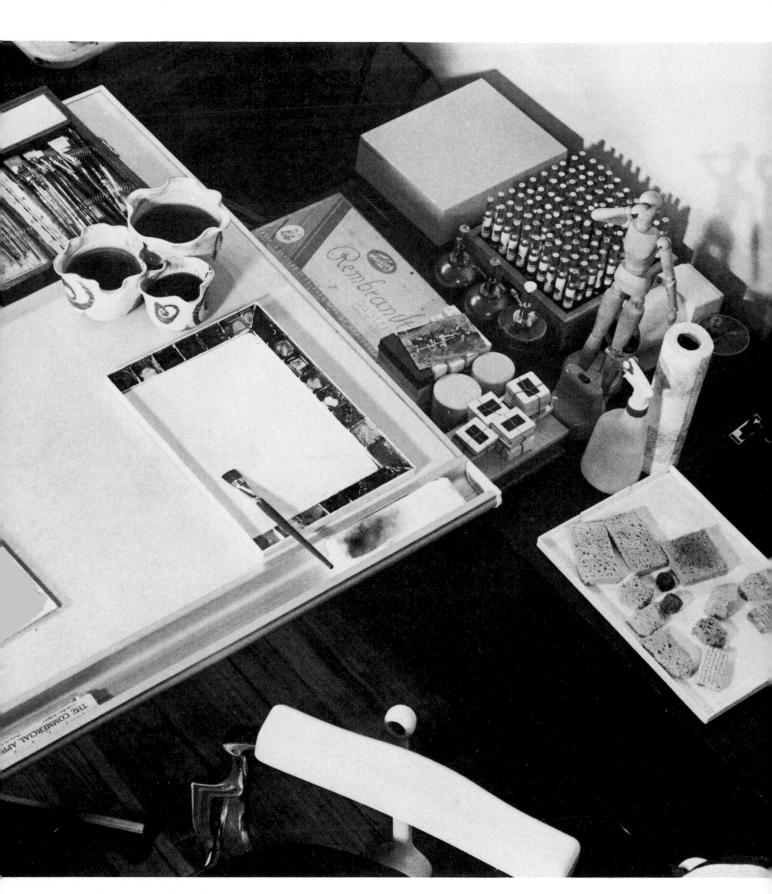

In my indoor setup, I have all my tools within easy reach: brush box, water container, palette and brush, sponges, spray misters, paper towels, and pencil sharpeners, among other equipment.

BASIC TECHNIQUES

The sixteen short demonstrations which follow can be a great timesaver in learning to work on hot-pressed surfaces. The use of these surfaces is still uncommon among serious watercolor artists, and no school or following has yet developed that teaches the proper use of hot-pressed surfaces for watercolor art. Having learned the following techniques through trial and error, I have conducted workshops whenever possible to teach others, but this book is my first real chance to cover all aspects of this wonderful and challenging surface.

I have devised these demonstrations to show *what* can be done with the hot-pressed surface and to show *how* to do it. Since the artist creates and controls the texture on this surface, each of these demonstrations is in some sense an exercise in creating a different texture. But I also want to show the marvelous qualities of this surface for capturing light, for depicting delicate, transparent shadows, and for revealing precise detail. To underscore this versatility, I have included an additional, completed painting at the beginning of each demonstration. This painting shows yet another usage for the technique being discussed.

All these exercises are done on Strathmore Hi Plate Illustration Board, cut to 10″ × 15″ (25 × 38 cm). This is the smoothest watercolor surface of all, and I lay the board flat when I paint on it so that the pigment will stay in place. The sketches are done with a 2B pencil, unless noted otherwise, and my brushes are limited to a couple of chisel-edged brushes, two or three pointed sable brushes, and occasionally a dagger striper or stiff-bristle brush.

My palette is also limited to five or six basic colors, and I get variety by mixing these in many combinations. Incidently, whenever I speak of a mixture of colors, here is what I mean: I dip the brush in clear water, then use it to pick up the paint I want from the well and transfer it to the palette. Then I dip the brush in water again, pick up a second color, and mix it with the first color on the palette, using the brush in a swabbing motion. Of course, the density of the mixture is determined by how much water I have allowed on the palette, and I sometimes add a little more water by squeezing it onto the mixture from a sponge. I determine the proportions of the pigment visually, adding a little of each color until I get the exact shade I want. The only exceptions to this procedure are surface color mixing and wet-in-wet wash; in both cases the colors are mixed on the board itself.

You will notice that I use the first three steps of each demonstration to show you how to do one basic technique, and I use the fourth step to complete the demonstration painting as a whole—often with other procedures discussed in this section. My theory in painting is that the end result should be of more importance than the means by which it was achieved, so the techniques you use should never attract more attention than the final picture.

One of the great advantages of working on hot-pressed surfaces is that you can complete particular areas of a watercolor at a time, before you work on other areas, because you can blend the edges of separate sections together after the painting is dry. This method is possible on hot-pressed surfaces because the color literally lies on the surface and does not penetrate; thus edges can be blended at any stage. Try doing some of these demonstrations yourself, or choose other subjects that lend themselves to the technique you want to attempt. But above all, don't be afraid to experiment, since that is the quickest and surest way to learn what this unique surface has to offer you as a serious watercolor artist.

FLAT WASH

A flat wash is an application of color without any variation in tone or density. This basic watercolor technique is useful for painting sky or water areas or any other large area which requires a single tone. It can also be used to create shadow areas of a continuous color density or to lay down an undertone, which is a basic color tone that will be painted over later. Another term for this procedure is color keying, which consists of laying a flat wash over the entire board. Painting details over this wash results in a painting with a consistent, overall color. A good use for color keying is for painting a sunset, in which the color-keyed board affects each color applied and gives the entire painting an overall, warm glow.

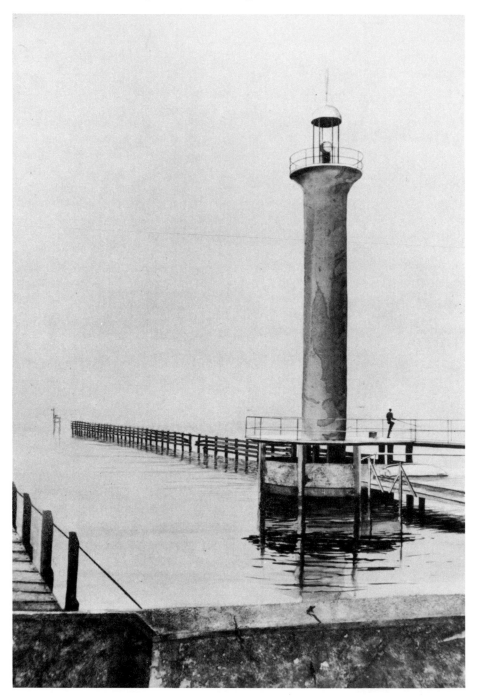

LIGHTHOUSE, 20″ × 30″ (51 × 76 cm). I saw this lighthouse scene early one summer morning in Biloxi, Mississippi, and its unreal quality captivated me. A heavy mist completely obscured the horizon, and the lone fisherman added a touch of drama. Here I used the flat-wash technique to create an almost monochromatic painting, using Davy's gray to suggest the overhanging fog.

STEP ONE. I sketch in the horizon, the diagonal shoreline, and the boats with a 2B pencil to establish the foreground, the middle area, and the background of the painting. Next, I use a synthetic sponge to slightly moisten the sky area with clear water, drawing the sponge back and forth across the board until the area is reasonably damp. I then mix Winsor blue and Davy's gray on the palette. It is important to mix enough wash to cover the entire area before beginning to paint; otherwise, the tone may not be consistent. Experience will help you to know how much wash to mix.

Picking up the mixture with a ¾" (19 mm) chisel-edged brush, I drag it across the top of the board in a single, fluid motion. Picking up another brushload of the same mixture, I make another horizontal stroke across the board, slightly overlapping the one above. I progress down the board in overlapping strokes until the entire sky area is filled in. It helps to keep the board tilted slightly toward you during this procedure so that each stroke will blend with the last for an even tone.

STEP TWO. I moisten the water area with clear water using a ¾" chisel-edged brush (or, you could use the sponge again), being careful not to touch the sky area above, since this could cause bleeding or lifting of the previously applied color. I add a little more Davy's gray to the wash mixture on the palette to make the water slightly lighter than the sky. I use the ¾" chisel-edged brush to apply a flat wash over the water area in continuous, overlapping strokes. I let the wash cover the boats because I can remove this color later.

At this stage I increase the color density in the already-washed sky area by another application of Winsor blue and Davy's gray, premixed on the palette. This is not an easy step on the hot-pressed surface since the underwash has a tendency to "lift out." To avoid lifting out the color, make sure that the board is completely dry, then pull the second wash across the surface in gentle, uninterrupted strokes.

STEP THREE. I remove the pigment from the boats by wetting a clean ¾" chisel-edged brush and "painting" the boats with water. Then I blot the wet surface with a dry paper towel, lifting out all the color. Now, using a dark mixture of burnt umber, Prussian blue, and burnt sienna in a ¾" chisel-edged brush, I apply random strokes to block in the land area on both sides of the inlet and to the left of the boats.

STEP FOUR. I create rock formations in the land area by using a razor blade to scrape aside areas of wet pigment. These areas reveal the undertoning and represent the sunlit sides of the rocks, while the displaced pigment gives the rocks depth and shadow. Now I use a pointed sable brush dipped in Winsor blue and burnt sienna to add detail and shadow to the boats. Finally, I pull a thin, flat wash of burnt sienna and Winsor blue across the horizon line with a ¾" chisel-edged brush.

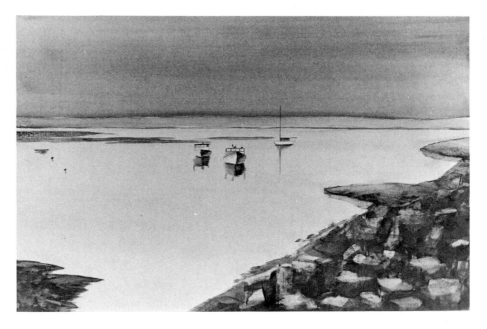

GRADUATED WASH

A graduated wash is an application of color which ranges from a darker to lighter value. The effect can be achieved by slightly tilting the board (or paper) toward you and pulling a brush loaded with color across the edge of the area you wish to paint. Then, with each successive stroke, you pick up a little more water with the brush, thereby lessening the color density as you work away from the original stroke. The graduated wash technique gives depth and suggests curvature, and it is therefore excellent for showing how light striking an object creates contour. Any round or cylindrical shape can be portrayed by this technique, and the barrel that I paint in the following demonstration is a particularly good example. Since it is curved, the direct light striking it practically demands that the graduated wash technique be used.

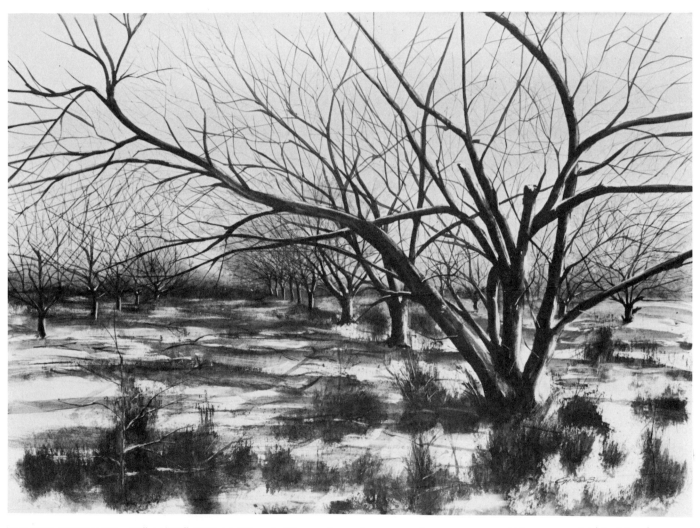

WINTER ORCHARD, 40" × 30" (102 × 76 cm). The setting sun produced a golden glow on the trees in this orchard, and my goal was to capture this lighting. I was also challenged by the dusting of snow that had covered the ground and the trees, wanting to represent it in an unpainted white. I created the sky in this painting by using a graduated wash: I turned the board upside down, pulled pigment across the horizon line, and then let it bleed into the sky area.

STEP ONE. I start with a drawing of a barrel done with a 4B pencil. The drawing will help to emphasize the details of the barrel after the wash is applied. I block in the tonal color over the drawing with a flat underwash of burnt sienna, using a ¾" (19 mm) chisel-edged brush. I use the flat wash technique described in Demonstration One.

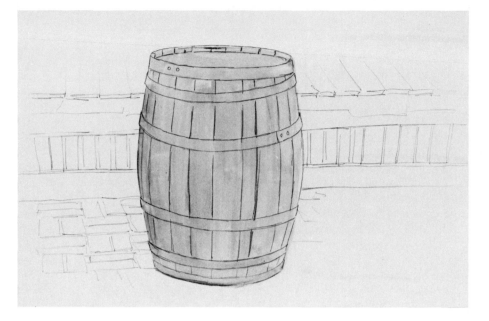

STEP TWO. I mix a dark color of Van Dyke brown and Prussian blue on the palette. Using a red sable lettering brush, I liberally apply this color to both sides of the barrel, using a single brushstroke on each side. I now give dimension to the shape by creating a tonal range from dark at the edges to light in the center. This is done by picking up clear water in the brush and pulling it from top to bottom through the heavily pigmented areas on either side of the barrel. The water in the brush mixes with the pigment and dilutes it, thus lightening the color. Each brushstroke is a single vertical motion slightly overlapping the previous stroke. As I paint toward the center of the barrel, each stroke contains more water and less pigment, and so the color thins out gradually. The curvature of the barrel, which is slightly off center, is highlighted by lifting out some of the color: I paint over the area with a ¾" chisel-edged brush dipped in clear water and then blot with a dry paper towel.

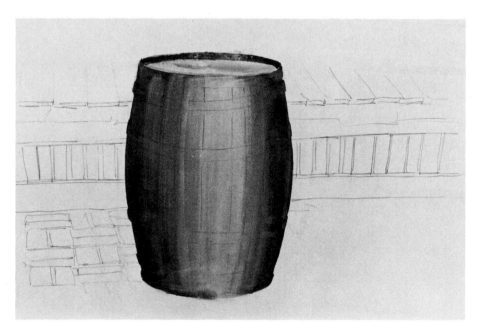

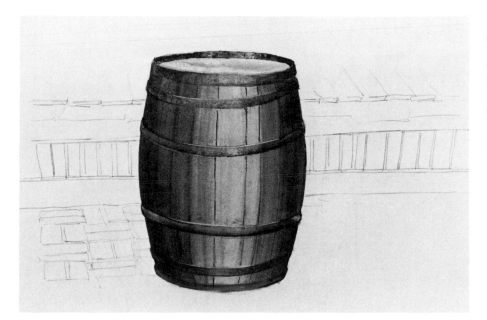

STEP THREE. I use a no. 8 pointed sable brush, loaded with a mixture of Van Dyke brown and Prussian blue, to emphasize the rings and staves of the barrel. I then use a clean pointed sable brush and clear water to lift a little color above the rings to suggest depth. This lifting technique is completed by blotting the area with a dry paper towel.

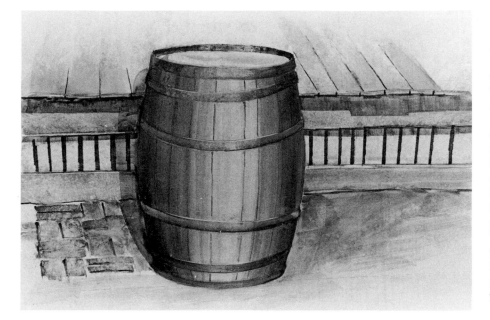

STEP FOUR. To complete the wooden platform, I mix burnt sienna and Winsor blue and apply a flat wash of this mixture to the entire wood surface with a ¾" chisel-edged brush. I also add touches of highly diluted burnt sienna to some of the boards for warmth and variety. I make a mixture of Prussian blue and Van Dyke brown, and using the sharp edge of a ¾" chisel-edged brush, I paint details and shadows on and around the platform. Now I use burnt sienna in a ¾" chisel-edged brush to paint the bricks in the foreground individually, picking up a bit of Winsor blue occasionally to vary the tonal range of the area. A thin wash of Prussian blue and Van Dyke brown painted in front of the barrel completes the foreground.

WET-IN-WET WASH

A wet-in-wet wash takes advantage of the tendency of watercolor to bleed or diffuse into an adjoining area of color. The technique works very well on the hot-pressed surface since the color lies on the surface of the nonabsorbent board, allowing the pigment to be manipulated by the painter as it floats about the surface. And because the hot-pressed board does not absorb the pigment the way usual watercolor paper does, the colors remain more intense after they dry. Since the drying time is longer, the colors may also take on an oxidized look.

The wet-in-wet technique is begun by wetting the surface of the

Color is squeezed from a sponge.

board with a sponge or brush loaded with lots of water. Then color is mixed with the water on the palette and applied to the wet area of the board, either with a brush or by squeezing it from a sponge. As you will see, additional colors can be applied and floated or run into previously washed areas to achieve many fascinating effects. The final result is a combination of manipulation by the artist and "happy accident." The wet-in-wet technique is good for depicting sky, fog, and early morning mist, and it is particularly useful for painting cloudy skies. It is also effective for underbrush, densely wooded areas, or distant trees, where the artist wishes to avoid a hard-edged tree line.

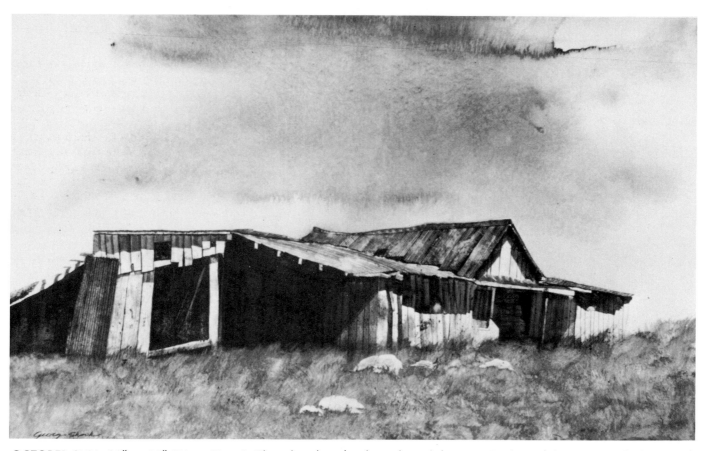

OCTOBER SUN, 30" × 20" (76 × 51 cm). This abandoned farm storage building had an abstract quality that I liked: the interplay of sunlight and shadows created abstract shapes, and the autumn sky offered an interesting background for these design elements. I achieved the overcast sky by using a wet-in-wet wash, floating and swirling Winsor blue and then Davy's gray onto the surface of the board.

STEP ONE. A detailed pencil drawing of a barn done with a 2B pencil defines the middleground of the painting. I use the wet-in-wet technique to paint the sky area. To begin, I dip the sponge into clear water and squeeze it slightly as I draw it over the sky area of the board until the surface is quite wet. I am careful to wet only that area of the board which will be the sky, since the wash will float into other portions of the board if they are also wet. Next, I mix Winsor blue with water on the palette and drip it onto the wet surface with a small round sponge. (You could also brush the highly diluted color on with the same results.) Then I simply lift the board and tilt it in various directions to allow the paint to "float" about the sky area. Since the pigment will not travel outside the prewetted area, I can easily control the color flotation.

STEP TWO. Now I apply the same color a second time while the area is still wet. This increases the color density and causes a swirling effect suggestive of a stormy sky. The area should be kept very moist to avoid hard edges. If the surface begins to dry, clear water may be applied by using a spray mister or by squeezing water from a sponge. The mister is used for this demonstration, but I have used both techniques with equal success.

STEP THREE. To add color I mix Davy's gray and water on the palette and squeeze this mixture from a sponge onto the still wet underwash of Winsor blue. This second color is then floated about in the particular area where I want a cloud. Don't forget to keep the board wet during this procedure because this will give you a smoother surface and cause the colors to float more freely. Any excess water and pigment can be floated to the edge and then blotted off with a dry paper towel.

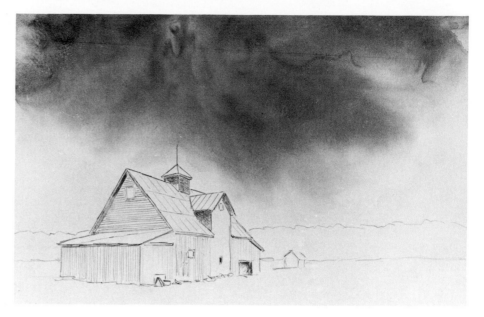

STEP FOUR. Since the dried Davy's gray has left some hard lines in the sky, I spray the area once again with the mister. This diffuses the edges and reduces color density. Now I paint the barn, using only a ¾" (19 mm) chisel-edged brush. I apply a wash of Davy's gray to the entire barn and then blot it with a wet paper towel. To complete the light side of the structure, I add a little burnt sienna to the Davy's gray on the palette and apply a second wash on that side. For the shadow side, I add Prussian blue and Van Dyke brown to the Davy's gray and apply a second wash. Then I apply a wash of burnt sienna to the roof. I paint the small outbuilding in the rear in the same manner.

Finally, for the grass and trees, I use two techniques which will be fully demonstrated later—the sponge and stiff-bristle-brush techniques. I start with slightly diluted portions of olive green, Winsor blue, and burnt sienna, each kept separately on the palette. I pick up bits of each pigment together in a wet, round sponge and dab it onto the background to create a line of distant trees. Then I use a stiff-bristle brush to create the foreground grass: I pick up the same pigments together and apply them in jabbing upward strokes that suggest the texture of grass.

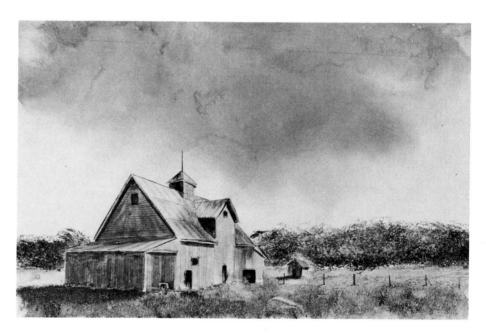

LIFTING OUT

When an artist says that hot-pressed surfaces are forgiving, he or she is probably thinking of the lifting-out technique. Pigment can be lifted from the surface of the board, allowing the artist to work from white in that area rather than having to paint over an undercoat. This technique also allows the artist to first paint in a consistent background and then lift out the foreground subject, rather than having to paint in the foreground subject first and then having to paint the background

A wet brush is used to lift out color.

around it. By lifting out the tree in this demonstration, for instance, a smoother background is preserved.

Although this demonstration shows color being lifted out from a large area of the painting, lifting out can also be used to create highlights in smaller areas by using a fine brush loaded with clear water. Other forms of lifting out are negative spatter, which is shown in Demonstration Eleven, and wiping, which is shown in Demonstration Thirteen.

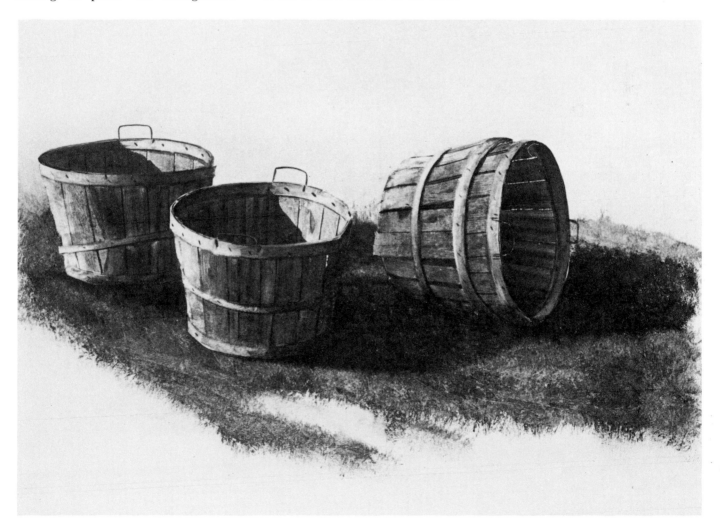

FOUR BASKETS, 30″ × 20″ (76 × 51 cm). I saw these baskets thrown to one side of a fruit-and-vegetable stand and was fascinated by the combined real and abstract arrangement. The baskets made such a sturdy utilitarian statement, while the sunlight striking their insides created hard-edged designs. In this painting the lifting-out technique was most important in the final step, to create the highlights on the sunlit sides of the baskets.

STEP ONE. I make a sketch using a 3B pencil. Then I squeeze olive green and burnt sienna from the tubes onto separate areas of the palette and pick up some of each color with a stiff-bristle brush. I apply the undiluted colors to the dry board and mix them on the surface with short, choppy, forward strokes. This is called surface color mixing. After surface-mixing, I blot the area with a wet paper towel to add more texture. I've now established the foreground and middleground areas of grass.

STEP TWO. Next I mix Davy's gray and a little burnt sienna with water on the palette, and using a ¾" (19 mm) chisel-edged brush, I block in the sky area. I pull the color freely across the dry board using side-to-side brushstrokes to cover the entire area, including the tree.

STEP THREE. After the sky area has dried, I use a ¾" chisel-edged brush to wet the tree area with clear water in preparation for lifting out. I then blot the wet surface firmly with a dry paper towel to lift out the color. The tree is now white again and ready to be painted. I also "draw in" the roots of the tree by lifting pigment from the foreground with a ¾" chisel-edged brush and clear water and blotting with a dry paper towel.

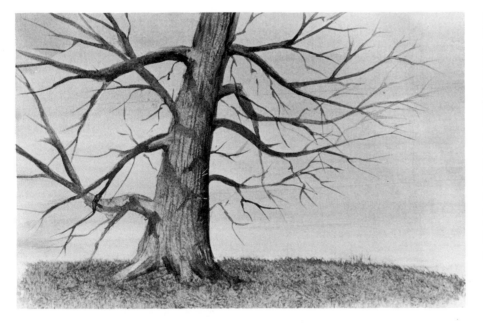

STEP FOUR. Using a ¾" chisel-edged brush, I now block in the tree trunk with an underwash of burnt sienna. I allow this underwash to dry, and then I mix burnt sienna with a little Winsor blue and Van Dyke brown and apply it to the sunlit side of the tree with the same brush. Next I add Prussian blue to the mixture and paint the shadow side. I use a pointed sable brush to paint the branches, using the same mixtures I used on the tree trunk for light and shadow sides. Finally, I intensify the shadows in places by further applications of Prussian blue and Van Dyke brown, mixed on the palette and applied with a ¾" chisel-edged brush.

STIFF-BRISTLE-BRUSH TECHNIQUE

Weeds, grass, and undergrowth can be realistically rendered by using the stiff-bristle-brush technique. This technique is also excellent for achieving the effects of rough textures such as aged wood or broken cement walls. The advantage of the hot-pressed surface is that it allows you to literally move the pigment around on the board for the desired effect. First you apply the slightly diluted pigment to the board in broad

A stiff-bristle brush is used to create texture.

strokes. Then you use the stiff-bristle brush to create the texture desired, such as the weeds in this demonstration. Note that it is important for a fair amount of moisture to be maintained in the brush; otherwise, the brush will dry out and fail to create the desired effect. A stencil brush, an oil painting brush, or any brush with very hard bristles such as hogs hair can be used in this technique.

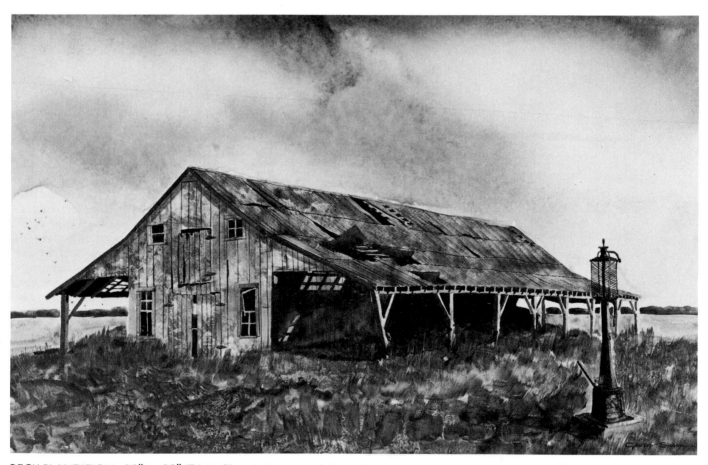

BECK PLANTATION, 30" × 20" (76 × 51 cm). I imagined this old farm building was once a much used structure, but now it had lost its purpose and looked quite forlorn. The rich array of grass in the foreground provided a good contrast to the deteriorating building, and the stiff-bristle-brush technique worked beautifully here. I blended olive green, burnt sienna, and ultramarine blue in the grass area, simply scrubbing the pigment so as to avoid fine detail.

STEP ONE. I use a 4B pencil to draw a group of rocks and to sketch some small trees growing near the rocks. I make a dilute mixture of burnt umber, Prussian blue, and burnt sienna (for warmth) on the palette and then block in an undertoning of color over the entire board. I create this undertoning by making broad, random strokes on the dry board with a ¾" (19 mm) chisel-edged brush.

STEP TWO. I mix burnt umber, olive green, and Prussian blue with a small amount of water, making sure the mixture remains thick. While the undertoning is still wet, I use a clean stiff-bristle brush to apply this mixture to the board, forcefully pushing the brush onto the board in a series of short, forward strokes. This action creates the texture, since the bristles actually leave their marks in the heavy pigment. I use an oil painting brush for this operation, because it holds up well under this kind of abuse and is inexpensive to replace.

STEP THREE. I use two methods for detailing. First, while the paint is still wet, I use the sharpened end of a wooden brush handle to "incise" individual weeds from the undergrowth as an accent. This procedure leaves a negative line where the brush end has displaced the paint, while the displaced pigment becomes the shadow side of the line, or weed. After the paint dries, I use a second method of detailing. This involves painting in additional weeds of a darker value with a pointed sable brush dipped in moderately diluted burnt umber.

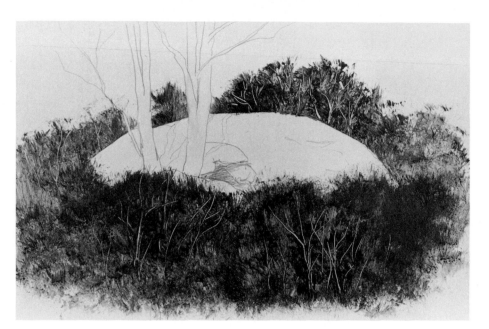

STEP FOUR. Now I use a ¾" chisel-edged brush to block in the rocks with Davy's gray. I blot the wet pigment with a damp sponge to give the rocks some texture. Then I use a ¾" chisel-edged brush to apply a mixture of burnt sienna and Winsor blue to the trees, and I use a ¼" (6 mm) chisel-edged brush and a highly diluted mixture of Prussian blue and Van Dyke brown to add shadows to both the trees and the rocks. I finish by adding touches of burnt sienna to the trunk for warmth with a pointed sable brush.

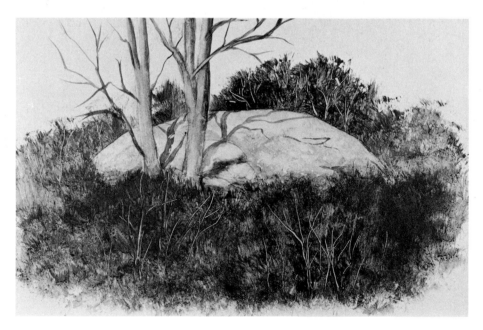

SURFACE COLOR MIXING

Surface color mixing is similar to the stiff-bristle-brush technique, in that the same forceful brush movements are used. There is, however, a significant difference between the two procedures. In the stiff-bristle-brush method, pigment is first mixed on the palette and then applied to the board; in surface color mixing, however, the individual colors are applied separately to the board and then mixed on the surface by the action of the brush.

Surface color mixing is unique to hot-pressed surfaces, since regular watercolor paper absorbs the pigment before it can be moved around. This technique is especially good for landscapes because color density can be controlled by the amount of water which is added to the pigment. For example, by using this procedure to make a background lighter, a scene is given perspective.

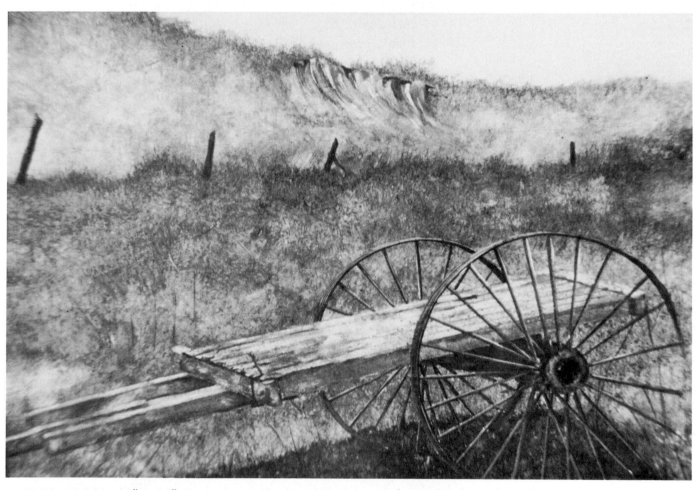

PASTURE WAGON, 30" × 20" (76 × 51 cm). This hay wagon was abandoned in a flat pasture, and I wanted to paint it but decided to make the background more interesting. So, when I drew the scene in my studio, I added the fence posts and a rolling hill with an eroded bank in the background. I used surface color mixing first to vary the tones and hues of the grass on the hill. Then, to create the foreground grass, I surface-mixed olive green, burnt sienna, and ultramarine blue.

STEP ONE. I use a 4B pencil to draw a rock wall and trees. Then I block in the foreground with a ¾" (19 mm) chisel-edged brush loaded with a diluted olive green. This serves as the under-toning.

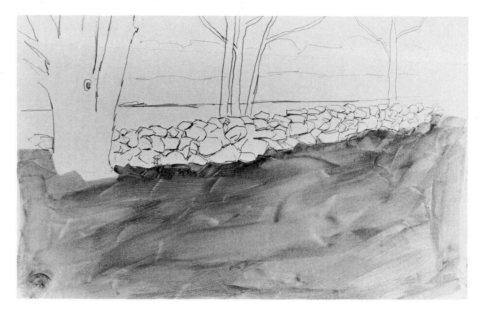

STEP TWO. Now I squeeze olive green, burnt sienna, and Winsor blue from the tubes onto separate areas of the palette. I then pick up some of each undiluted color with a ¾" chisel-edged brush and dab this brushload of pigments onto the board, which is still wet, in preparation for surface color mixing.

STEP THREE. I mix the colors on the board by making short, choppy, forward strokes into the wet pigment with a stiff-bristle brush. The bristle marks left by these short, choppy strokes create a texture that adds to the realism of the grassy foreground. Although the surface-mixing action mingles the colors, the colors are not completely blended, and a variety of hues is still preserved.

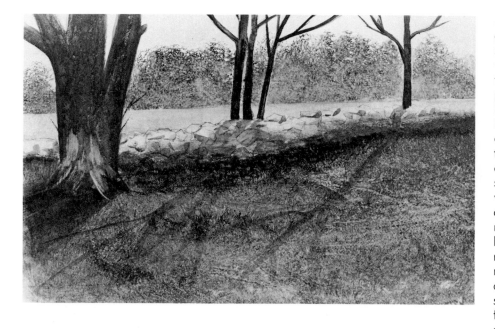

STEP FOUR. I use a mixture of Davy's gray and burnt sienna in a ¾" chisel-edged brush to block in the rock wall. Then I blot the wet area along the top of the wall to give it a sunlit appearance. Now I dip a sponge into a barely diluted mixture of olive green, Prussian blue, and burnt sienna and dab the sponge across the background to produce the distant line of trees. I create depth by using a clean, damp sponge to lift an area behind the rock wall. To give the trees a backlighted appearance, I paint them with a dark mixture of Prussian blue and Van Dyke brown in a ¾" chisel-edged brush. A much thinner mixture of the same pigment is used to paint the shadows across the grass. Finally, using a damp sponge, I wipe away a little pigment from the base of the largest tree to add an interesting texture.

BLOTTING FOR TEXTURE

This technique starts with surface color mixing, but by going a step further it offers different and more varied textures. After colors have been surface-mixed, a damp paper towel or any other absorbent paper or cloth is used to blot the painted area. The procedure lifts out some of the pigment and leaves an imprint of the wrinkles from the towel. When the same blotting material is re-applied to the area, it lays down again some of the pigment it had

Pressure is applied to a damp paper towel to create texture.

picked up previously. Repeated blottings therefore give a different effect each time, and experimentation will produce a wonderful variety of textures. Blotting, which is most effective on the hot-pressed surface, has numerous applications, including grass, weeds, distant trees, and the textural effects of aged wood, bricks, or cement surfaces. The demonstration beginning on the next page will use blotting to create grass around a basket.

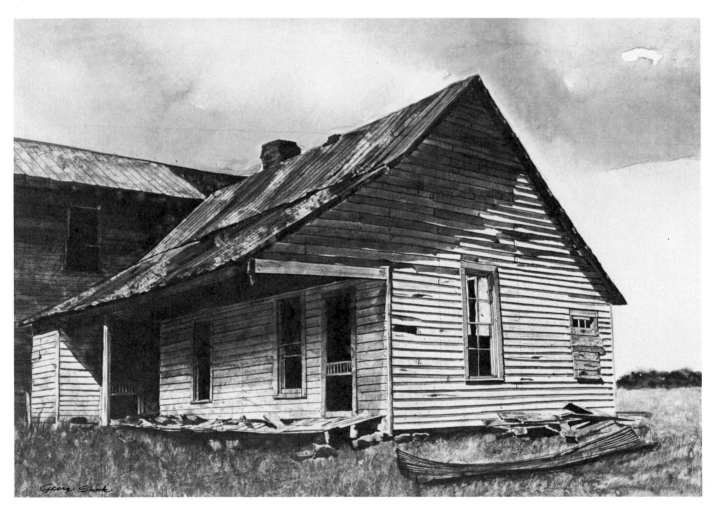

PART OF THE BIG HOUSE, 40″ × 30″ (102 × 76 cm). The relic of a pre–Civil War plantation home, this house was painted on location in eastern Tennessee, near Chattanooga. The old, oxidized clapboard had a rosy glow, and its tex- tures contrasted nicely with the graphic shadows caused by the bowing of the boards. To achieve the distinctive weath- erbeaten character of the scene, I constantly blotted the wood, corrugated tin, and grass areas for texture.

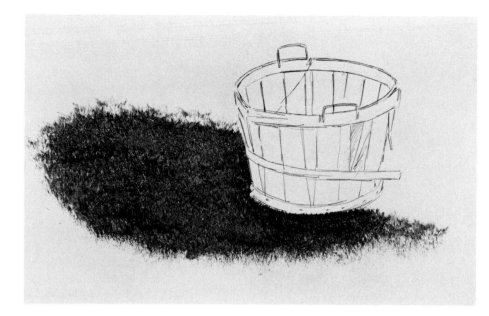

STEP ONE. I use a 2B pencil to make a detailed drawing of a basket. Next, I use a ¾" (19 mm) chisel-edged brush to apply a moderately diluted wash of olive green to the grass area. I then use the same brush to pick up a little pure burnt sienna, and I apply it over the olive green in a few spots to add some warmth.

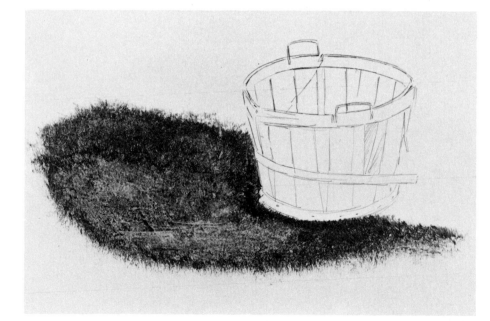

STEP TWO. While the area is still wet, I use a clean stiff-bristle brush to mix the colors on the surface with short, choppy, upward movements. Now I wet a paper towel and wring it out slightly so that when it is used no water will drip from it. I lay the damp paper towel over the painted area and run my hand across it to make sure that the towel is in complete contact with the surface of the board. Then I lift the towel to see what interesting textures I've created. I prefer to use ordinary paper towels for this procedure because they bring their own texture to the method.

STEP THREE. After the paint has dried, I blot again for additional texture. As before, I squeeze water from a wetted paper towel, smooth the towel out slightly, and lay it over the painted area. I run my hand over the towel, pressing it into contact with the surface, and then I remove it. If this final effect isn't satisfactory, more blottings will give alternative textures.

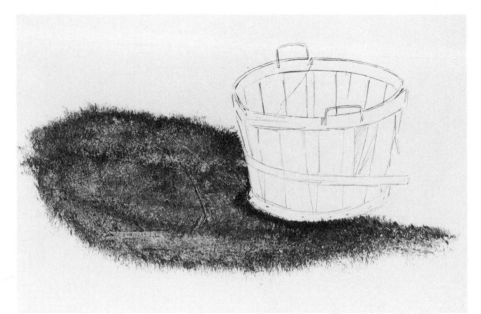

STEP FOUR. I begin painting the basket by using a ¼″ (6 mm) chisel-edged brush and a mixture of Davy's gray and burnt sienna to lay a thin wash over the entire form. I blot the area with a damp paper towel to create texture. Next, I use the same brush to paint the individual wood strips of the basket. I vary the mixture each time, picking up some extra burnt sienna in one stroke, adding more Davy's gray to the next, adding a little Winsor blue to the next, and blotting after each stroke with a damp paper towel. Finally, I mix Prussian blue and Van Dyke brown and use a ¼″ chisel-edged brush to add shadow inside the basket and to the right of it, once again blotting for texture.

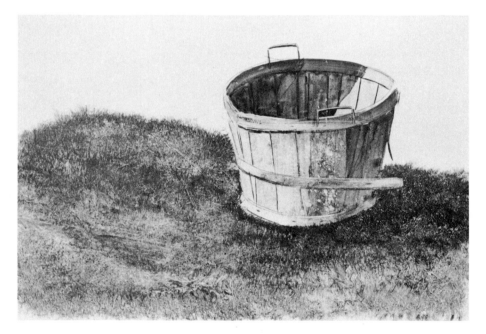

SPONGE TECHNIQUE

The sponge technique is another variation of surface color mixing. While surface color mixing is a technique that moves color around on the surface only, the sponge technique lifts and lays down different pigments, thereby creating layers of colors. Because repeated dabbing of the sponge mixes the color better, this technique also allows a more consistent hue than surface color mixing.

Since the sponge produces a tex-

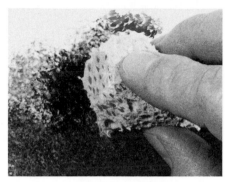

Texture is created by dabbing with a sponge.

ture similar to foliage, it practically "draws" bushes and hedges for you. A large-holed, more porous sponge is a natural for doing trees. I suggest you use a synthetic sponge, since natural sponges tend to disintegrate when left moist. Natural sponges are much softer and therefore lack the resistance, or bounce, of synthetic sponges. They also tend to apply globs of paint instead of actual textures to the surface.

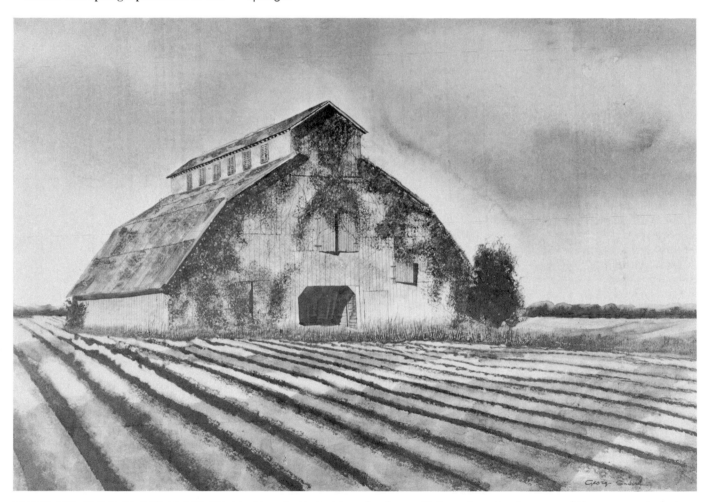

NOVEMBER SUNDAY, 28″ × 19″ (71 × 48 cm). Probably because it looked so unusual, I was commissioned to paint this barn by the Beck Plantation in Arkansas. A sprawling structure in the middle of a plowed field, among patches of grass and a small tree, the barn even had ivy growing pro-

fusely on it! I made extensive use of the sponge technique here, using a sponge to dab in the plowed fields in the foreground, the grass and tree beside the barn, and, of course, the ivy.

STEP ONE. I use a 2B pencil to draw a wheelbarrow as the focal point of the painting. Then I block in an undertoning of olive green in the background with a ¾" (19 mm) chisel-edged brush, using broad, random strokes.

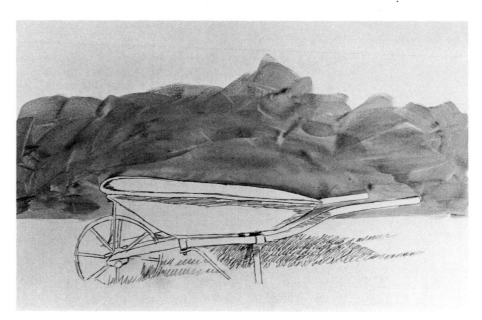

STEP TWO. Now I squeeze olive green and burnt sienna from the tubes onto the palette and mix each with a very small amount of water. Then I pick up some of each color with a small, round sponge and dab the sponge onto the area above the wheelbarrow. The shape and texture of the sponge creates a realistic impression of foliage. I dab selectively so that some of the underpainting shows through, thus adding depth.

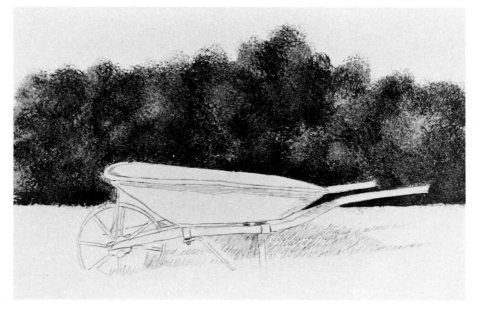

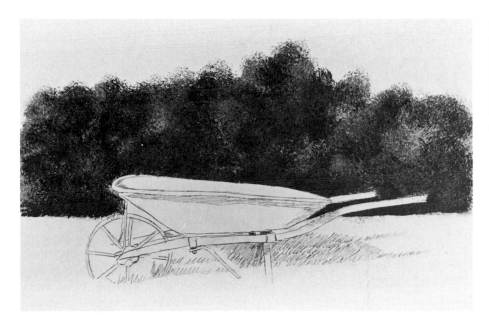

STEP THREE. I now add shadows to the foliage by sponging on a mixture of Prussian blue and Van Dyke brown. A sponge gives the artist very good control: you can darken areas by adding more pigment or lighten them by lifting out pigment with a clean, damp sponge.

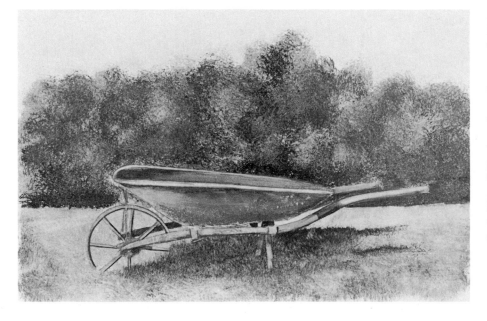

STEP FOUR. I vary the density of the hedge by dabbing a damp sponge onto selected areas to lift a little pigment. Next, I use a pointed sable brush loaded with a mixture of Winsor blue and burnt sienna to paint the wheelbarrow. The grass in the middleground and foreground is added by surface-mixing olive green and burnt sienna with a stiff-bristle brush. I now complete this painting by adding detail and shadow in and around the wheelbarrow with Prussian blue and Van Dyke brown. I use a pointed sable brush for detail and a ¾" chisel-edged brush for shadow.

IMPRINTING

Imprinting is the technique of using the particular design or texture of an object to make a mark or pattern on the painting surface. You pick up paint from the palette with the chosen object, press it onto the surface, and remove it, thus leaving its imprint. Any number of instruments can be used in this technique, with each leaving its own characteristic mark. In the next demonstration, a synthetic sponge bought at a local hardware store is used to reproduce a

The type of material and its pattern determine the texture.

brick pattern. Other materials I've used are corrugated cardboard, wire screen, and hardware cloth.

Imprinting works nicely on the hot-pressed surface, leaving a crisp, bold pattern of color. The method can be used to depict stone or brick facades, aged tin, rusty metal, weathered wood, or to create other interesting effects. Be creative. Experiments will show you how common objects can enhance the interest and realism of your paintings.

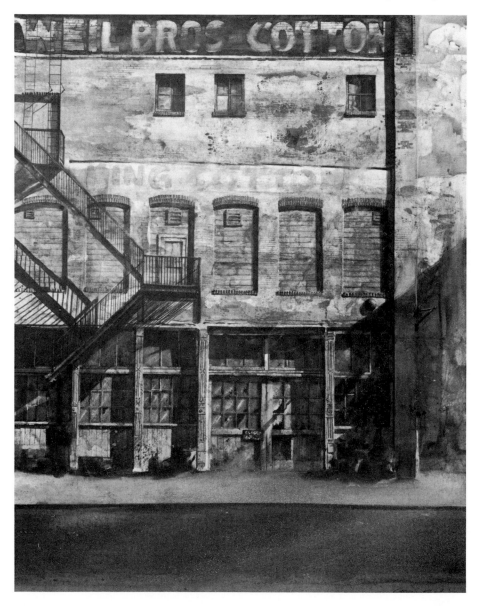

WHEN COTTON WAS KING, 30″ × 40″ (76 × 102 cm). Weil Bros. is an old and prominent business located on the riverfront near my studio. One of the many cotton companies in downtown Memphis, it tells of the importance of that industry to the city's history. The imprinting technique was essential in creating the texture of the building facade. To achieve that patchy, weathered look, I pushed a rubber roller across the entire surface while the pigment was still wet.

STEP ONE. I make a sketch of the facade I am going to imprint. Then I use a ¾" (19 mm) chisel-edged brush to randomly block in the facade area with Davy's gray. I blot the wet area with a damp paper towel to create the underlying texture.

STEP TWO. While the paint is still wet, I dip my brick-patterned sponge into a mixture of burnt sienna and cadmium red, premixed on the palette, and touch the sponge lightly to the wall area to create the brick effect. I repeat this process until I've covered the entire area that I wish to imprint.

STEP THREE. Now I make a mixture of Prussian blue and Van Dyke brown, and, with the same sponge, I dip into this mixture and repeat the imprinting process. By making this second imprinting slightly off register, I create the illusion of depth.

STEP FOUR. Finally, I block in the wood door with a ¾" chisel-edged brush and a mixture of Davy's gray and burnt sienna, blotting with a damp paper towel. With the same brush I apply a mixture of Prussian blue and Van Dyke brown to the windowpanes, and then I add Winsor blue to the door panels. Still using the ¾" chisel-edged brush, I paint shadows on the doorway with a mixture of Prussian blue and Van Dyke brown. Then I add grass to the foreground by surface-mixing olive green and burnt sienna with a stiff-bristled oil painting brush.

POSITIVE SPATTERING

Positive spattering is the technique in which fine specks of pigment are randomly spattered onto a painted area to create a desired texture. So positive spattering results in a texture that is actually added to the original painting. Any stiff-bristle brush, such as a toothbrush, oil painting brush, or stencil brush, can be used in this technique. You create the spatter effect by loading your brush with some diluted pigment and then dragging another tool—another brush handle, a piece of

Pigment is flicked from a toothbrush to create positive spatter.

screen wire, or even your thumb—across the bristles so that the pigment springs onto your painting surface. This technique can be used to depict gravel, rusty or corrugated metal, wood, or any deteriorating surface. It can be used to depict snowflakes, by using opaque white paint, and it can be useful for adding detail to tree trunks. In the following demonstration, I will use positive spattering to add age and character to a rusty bucket.

DAISY CHAIN, 20″ × 26″ (51 × 66 cm). This was a study in design and textures: I felt challenged by the pronounced linear pattern of the boards and by the wood textures, which I wanted to recreate using painting techniques rather than extensive preliminary drawing. After blotting the boards for texture and adding details of the wood grain with a pointed sable brush, I used the positive-spattering technique to create a truly weathered-looking texture on the door.

STEP ONE. I use a 2B pencil to make a detailed drawing of a bucket and the fence behind it. I then use a ¾" (19 mm) chisel-edged brush to block in an undertoning of burnt sienna over the entire bucket.

STEP TWO. After the undertoning has dried, I mix Prussian blue and Van Dyke brown to be used for adding the shadow and detail. Using a ¾" chisel-edged brush, I apply the mixture to the right side of the bucket to create a broad shadow area. Then I switch to a pointed sable brush to add the finer details to the handle.

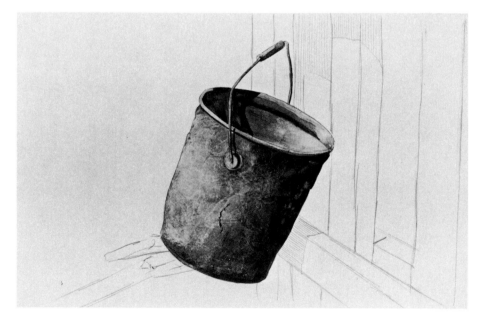

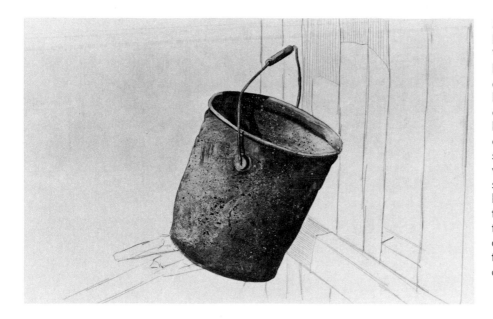

STEP THREE. At this stage I spatter the bucket. I pick up the Prussian blue and Van Dyke brown mixture with a toothbrush, hold the brush over the proper area, and drag my thumb across the bristles. The thrust of the bristles causes drops of paint to spatter all over the bucket. The size of the spatter depends on how far the brush is held from the surface, and in this case the toothbrush was held quite close. You can use any stiff-bristle brush for this procedure, but I seem to have better control over the direction of the spatter when I use a toothbrush. If desired, you can cover areas around the subject with a paper towel to protect them from stray drops of paint.

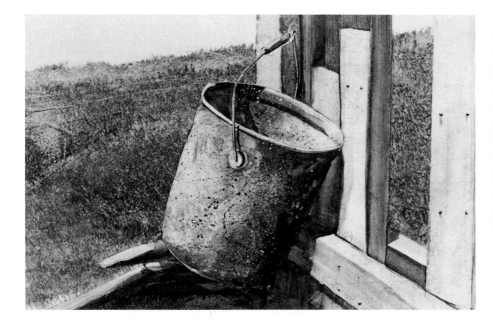

STEP FOUR. To complete the painting, I surface-mix olive green and burnt sienna to add grass to the back, middle, and foreground areas. I then blot the entire area with a damp paper towel for additional texture. For the wooden fence I mix a wash of Davy's gray and burnt sienna and apply it with a ¾" chisel-edged brush. Now I add shadows under the bucket by using the same brush loaded with a mixture of Winsor blue and Van Dyke brown. Finally, I paint in some rusty nails with a pointed red sable brush loaded with pure burnt sienna.

NEGATIVE SPATTERING

Negative spattering is the opposite of positive spattering in that the spattering action lifts out pigment from the surface of the board, rather than adds pigment onto it. In negative spattering, you flick clear water onto the surface—using the same instruments as in positive spattering—and then use a dry paper towel to gently blot away some of the pigment lifted by the drops of water. Since it incorporates the lifting-out technique, this technique is also unique to hot-pressed surfaces.

Negative spattering is usually used to lend a weatherbeaten look to wood or metal surfaces, such as the clapboard wall in the following demonstration. It is also excellent for creating a rocky shoreline. By spattering droplets of water of varying sizes onto the appropriate area, you will create the effect of contoured rocks. Then you can add a shadow to each rock for even greater realism.

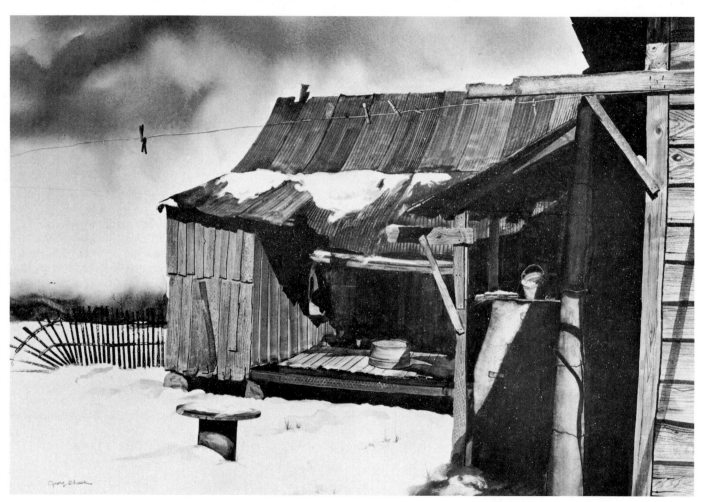

BENJAMIN'S SNOW, 40" × 30" (102 × 76 cm). I had nearly finished this painting on location in mid-summer when I decided it would make a good snow scene, and thanks to the hot-pressed surface I was able to indulge my fantasy. I lifted out pigment from the roof and added a few shadows to the roof and unpainted foreground—and so I had my snow! I then used negative spattering to create texture on the wood and metal. For the falling snow, I used opaque white paint and the positive-spattering technique.

STEP ONE. I make a detailed pencil drawing with a 2B pencil. Then I brush a highly diluted undertoning of Davy's gray onto the wall area with a ¾" (19 mm) chisel-edged brush. Next, I add separate portions of burnt sienna and Winsor blue to the palette, pick up small amounts of each with the Davy's gray in a ¾" chisel-edged brush, and paint the individual boards with single, continuous strokes. I pick up different proportions of the three pigments for each stroke. For example, I use more burnt sienna in one stroke and more Winsor blue in the next. Since actual weathered wood reveals a variety of colors ranging from warm pinks and yellows to cool grays and blues, this method lends a realistic touch. By giving each board an individual character, the entire painting becomes more interesting.

STEP TWO. Now I use a mixture of Van Dyke brown and Prussian blue in a pointed sable brush to emphasize the drawn lines of the wall, adding shadow under each board to give the appearance of clapboard. I prefer to paint these lines freehand to avoid the carefully drafted look of architectural rendering, but you may like to use a straight-edged guide to establish the first line or two.

STEP THREE. I am now ready to "age" the wood with negative spattering. I dip a clean toothbrush in clear water, hold it over the painting, and tap the brush against my finger so that droplets of water are flicked onto the surface of the board. I could have just as easily drawn a thumbnail over the brush, but that would have created a finer pattern of drops than I wanted here. After I've spattered the surface with clear water, I use a clean, dry paper towel to blot and wipe away the pigment lifted by the drops of water. Now I reemphasize the shadow areas using the Van Dyke brown and Prussian blue mixture in a pointed sable brush. While the negative spots still show through, this restoration of the shadows is necessary for realism since shadows lie over a surface and are always continuous.

STEP FOUR. In this final step, I paint the window. I use a ¼" (6 mm) chisel-edged brush to lay in a wash of Davy's gray and burnt sienna on the wooden window frame, and then I blot this area for texture with a damp paper towel. To paint the windowpanes, I begin with an underwash of Winsor blue in a ¾" chisel-edged brush. After this has dried, I use the same brush to add another wash of Davy's gray. Then I use my palm to lightly mix the colors on the surface by pressing my palm lightly into the paint and twisting it slightly while the pigment is still wet.

RESIST TECHNIQUE

The resist technique is an easy method used to protect specific areas of the board from paint. It is especially useful for saving a delicate drawing which pigment would degrade. The technique is accomplished by first applying an adhesive substance to any area that you want to keep free of paint. Then when you've finished painting the background and are ready to paint the protected area, you simply remove the resist and you have a clean,

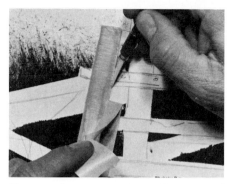

Tape used as a resist is easily removed from hot-pressed surfaces.

white area with which to work.

Ordinary watercolor papers must be masked with Maskoid, Misket, or rubber cement—which are all liquid resists that dry to a thin, rubbery film and can be easily removed by gentle rubbing. However, the hot-pressed surface is slick enough for you to use masking tape or Scotch tape without having the surface tear when removing the tape. You must be sure, of course, that the surface has completely dried first.

WILD FLOWERS, 30″ × 20″ (76 × 51 cm). When I saw the wild daisies and creeping kudzu surrounding this abandoned schoolhouse, I was struck by the contrast between the softness of nature and nature's potential to ravage and obscure. I wanted to paint the schoolhouse while it still held its own—before it became buried, like the memories of school days past. I left the flower areas an unpainted white by covering them with Maskoid before painting the hillock.

STEP ONE. I use a 2B pencil to draw a fence, a 55-gallon drum, and part of a collapsed roof. Then I carefully apply masking tape, my own favorite resist material, to the parts of the drawing that I want to protect. I trim the tape with an X-acto knife to fit the curves of the metal drum.

STEP TWO. I cover most of the board, including the resist area, with a mixture of Prussian blue, olive green, and burnt sienna using a ¾" (19 mm) chisel-edged brush. Then I make sharp, upward strokes into the wet pigment with a stiff-bristle brush to create the texture of grass and weeds.

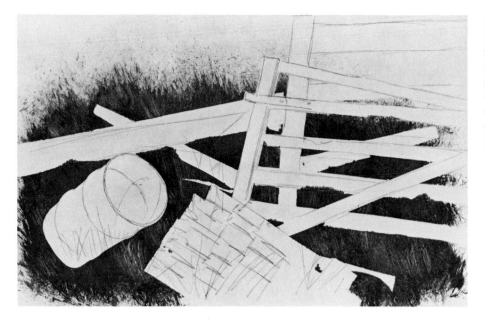

STEP THREE. After making sure that the paint has dried, I carefully remove the tape. Since the edges between the painted areas and the white resist areas are a little too hard, I soften them by dragging a wet ¾" chisel-edged brush over them. The hard lines are softened as the pigment bleeds into the unpainted areas.

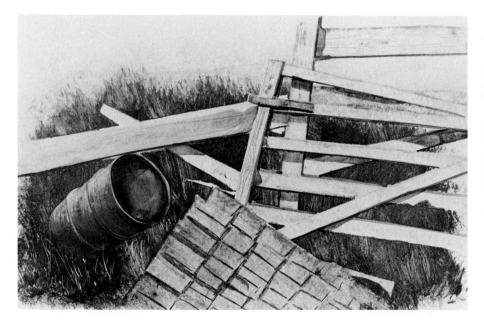

STEP FOUR. I paint the wooden fence and the broken roof with a ½" (13 mm) chisel-edged brush loaded with a wash of Davy's gray and burnt sienna, then blot the areas with a damp paper towel. Now I use the same brush to apply a mixture of burnt sienna, Winsor blue, and raw sienna to the barrel and gate hinge. Finally, I add shadows and detailing with a mixture of Van Dyke brown and Prussian blue in the same ½" chisel-edged brush, using the edge of the brush for the finer detail work.

WIPING

Wiping is another variation of the lifting-out technique, and so it too is unique to the hot-pressed surface. The difference between the two techniques is that while lifting out involves applying clear water and then blotting with absorbent material, wiping is accomplished in one step by directly wiping the pigment off with a wet sponge. Wiping also differs from lifting out in that wiping leaves a residue of color, and it leaves enough moisture around the

A wet sponge is used to wipe color from the hot-pressed surface.

edges of the wiped area for some pigment to bleed slightly back into it. This allows a more diffused edge and makes the technique very good for depicting surface erosion, as will be shown in the following demonstration. Wiping is also particularly effective for creating the sheen of glass. A gentle wipe across a painting that depicts glass will lift and streak a bit of pigment, suggesting the reflections typical of large glass windows.

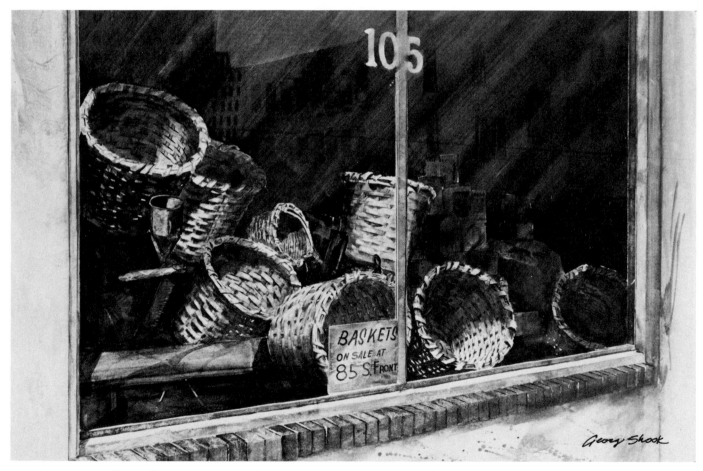

BASKET CASE, 40″ × 30″ (102 × 76 cm). This painting presented a special challenge because of the two focal planes in it: I wanted to show the sunlit baskets in the window and the reflections of the buildings across the street. The glass itself also had a brilliance that I wanted to capture, and the wiping technique helped me to do this. In the final step, I pulled a slightly moistened sponge diagonally across the surface, being careful to use a very light touch, and thus reproduced the sheen of the plate glass.

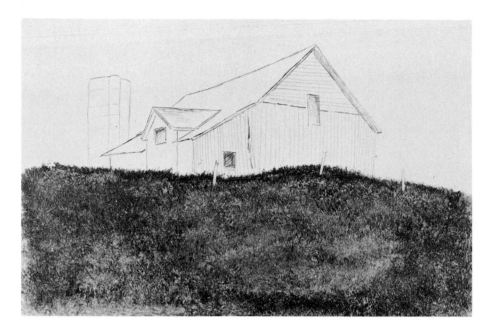

STEP ONE. I draw a barn and fence posts in the upper portion of the painting. Next, I use a ¾" (19 mm) chiseledged lettering brush to block in the entire hillside with olive green. Then, I surface-mix olive green, burnt sienna, and ultramarine blue with a stiff-bristled oil painting brush to give the area an appearance of grass and weeds. More texture is added by blotting the wet pigment with a damp paper towel.

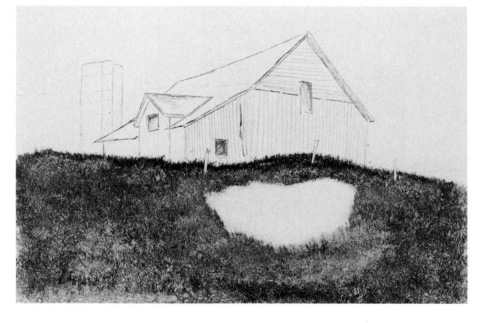

STEP TWO. Now, to lift out an eroded bank on the hillside, I use a clean, wet sponge to wipe the pigment from the area I've chosen. This takes the area back to pure white.

STEP THREE. While the wiped area is still wet, I load a ¾" chisel-edged brush with burnt sienna, mixed with very small amounts of Van Dyke brown and Prussian blue, and dab this mixture across the very top of the wiped area. Then I use my thumb to pull the color downward into the white area. A brush could also be used for this procedure, but the thumb seems to work better in getting that uneven look which erosion usually has. Now I blot the thin layer of color I have laid down with a damp paper towel and balance the color by pulling olive green from the hillside into the eroded area with a ¾" chisel-edged brush.

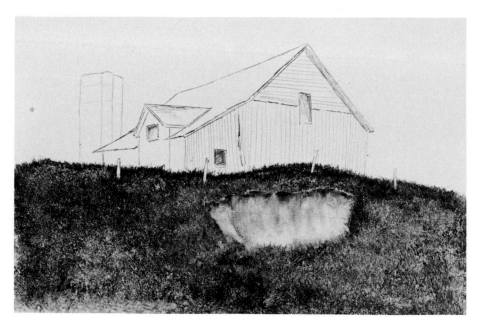

STEP FOUR. I paint the barn with a ¼" (6 mm) chisel-edged brush, using a wash of Davy's gray for the light side and adding burnt sienna for the shadow side. Then I use these same colors to paint the silo. The barn roof is painted with a mixture of burnt sienna and Winsor blue, and the shadows, windows, and door are done with a mixture of Van Dyke brown and Prussian blue. Finally, I apply a very light wash of Winsor blue to the sky area and add another light wash of the same color using the wet-in-wet technique to create some swirls.

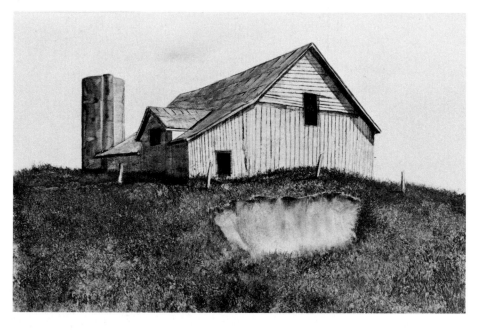

WET-OVER-DRY WASH

The wet-over-dry wash technique is an excellent method for depicting shadow areas, as in the following demonstration, which shows a long afternoon shadow against a wooden wall. The technique begins with a flat wash that is allowed to dry thoroughly. Then a darker wash is applied over the first wash to depict the shadow. The transparency of watercolor is perfect for achieving the effect of shadow, since the color and detail of the washed surface remains visible beneath the thin film of darker tone. This adds depth and interest to the painting.

It is best to first paint an entire scene in a condition of equal lighting—that is, with no shadows. Then a second wash is applied to represent the shadow, a technique which allows the artist greater control over depth, density, and length of shadow.

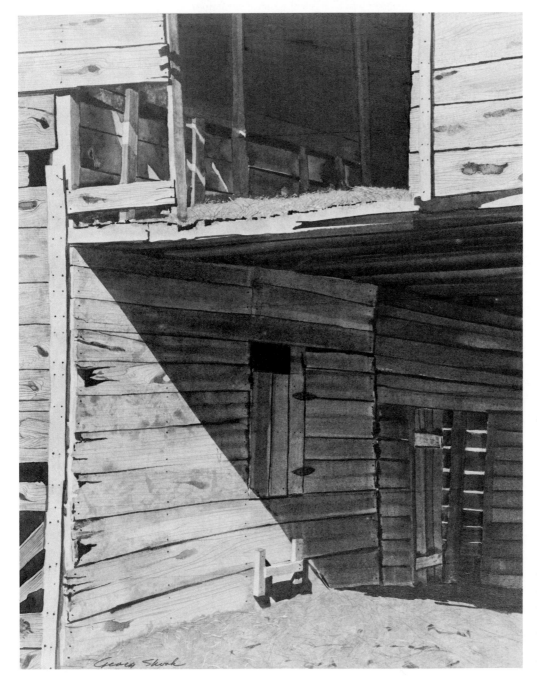

DAVE'S BARN, 21″ × 25″ (53 × 64 cm). What excited me about this seemingly mundane scene was the stark contrast between light and shadow areas and the linear shapes that this contrast produced. I accentuated the shapes even further by playing up the lighted areas while subduing the shadowed ones, and thus I created a composition that seems more abstract than realistic. The wet-over-dry wash was the perfect technique for adding shadow to the interior of this barn.

STEP ONE. I begin by drawing the scene with a 4B pencil, including a shadow line under the overhang to be used as a guide for the second wash. Then I block in the wall area with a thin, flat wash of Davy's gray in a ¾" (19 mm) chisel-edged brush. I blot the wet pigment with a damp paper towel to give the wood a weathered look.

STEP TWO. I now mix Van Dyke brown and Prussian blue with a lot of water to prepare for painting the shadows. I'm careful to mix enough color to complete all of the shadow areas so that the tone will be the same throughout. Then with a pointed sable brush, I paint a shadow under each plank of the wall, which I do freehand, taking care to have each shadow appear straight and consistent.

STEP THREE. Now I use the same mixture of Van Dyke brown and Prussian blue in a ¾" chisel-edged brush to paint the shadow of the stoop overhang. First, I make sure that the original wash is very dry; otherwise the color would lift back out. Then I apply the darker, second wash in smooth, continuous strokes from side to side. Remember that a brushstroke must be completed in a single motion on hot-pressed surfaces, or an uneven tone will result.

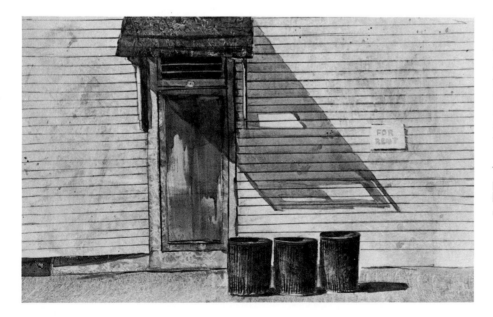

STEP FOUR. I finish the painting by mixing burnt sienna and Winsor blue, and then, using a ¾" chisel-edged brush, I apply this mixture to the overhang and trash cans. With the same brush, I now paint shadows under the overhang and beside the cans with a mixture of Prussian blue and Van Dyke brown. As a final thought, I decide to include a "For Rent" sign. I wipe the area first, and then, using a pointed sable brush, I paint the lettering with Davy's gray and burnt sienna. Lastly, I add a shadow under the sign to give it emphasis.

DRYBRUSH TECHNIQUE

The effects of the drybrush technique on hot-pressed surfaces are unique. While the surfaces of more absorbent watercolor papers have their own textures, the hot-pressed surface is so smooth that any texture must be created by the artist. One of the best ways to create textures is with a dry brush—a brush loaded with diluted paint, which is then blotted to remove the moisture, using a dry paper towel. The towel can even be wadded and touched to

Excess moisture must be removed from the brush.

the heel of the brush to draw away moisture without removing too much pigment.

The drybrush technique creates a satinlike finish when the brush is dragged across the surface. Further, the degree of texture varies according to the amount of moisture remaining in the brush, with a drier brush creating a rougher texture. This great textural control is useful for a wide range of effects, including weathered or rusty finishes.

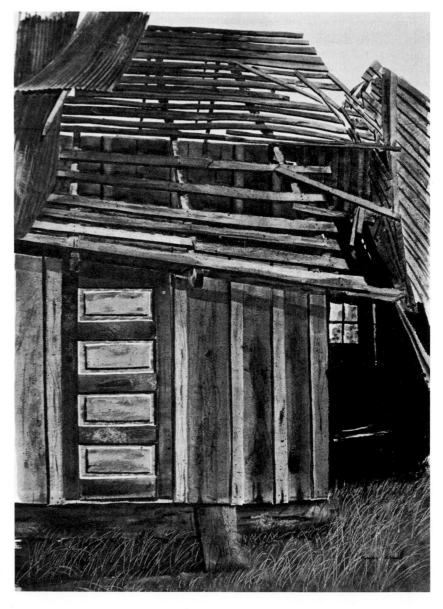

TUMBLIN', 18″ × 24″ (46 × 61 cm). When I discovered this abandoned house, which was severely damaged by a storm, it revealed a fascinating pattern of linear shapes that I found irresistible. First, I made a rough drawing to fix the arrangement of the siding, rafters, and roof support. Then I used the drybrush technique to create the special textures that I felt the scene deserved.

STEP ONE. I begin by making a detailed preliminary drawing with a 2B pencil. Then I block in the metal areas of the lantern with a pointed sable brush dipped in a thin wash of burnt sienna. I blot the area with a dry paper towel while the area is still wet to create a slight texture. This texture will be enhanced in the next step by the use of the drybrush technique.

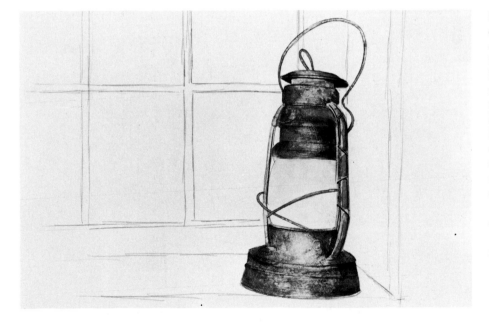

STEP TWO. After the paint has dried, I employ the drybrush technique to add detailing to the lantern. I begin by picking up a thin mixture of Van Dyke brown and Prussian blue with a pointed sable brush. Then I remove the excess moisture from the bristles by wiping the brush across a folded paper towel. Now I drag the brush, with the almost dry pigment on it, across the burnt sienna undertoning. The uneven pigment which is left on the surface creates a rough texture and gives the lantern a rusty appearance. I mix the same colors, only adding more pigment and less water, and use the same pointed sable brush to add a shadow to the right side of the lantern.

STEP THREE. Now I use a ¾" (19 mm) chisel-edged brush to add a graduated wash of Winsor blue and Van Dyke brown to the glass chimney. By merging the light area into the shadows, I give the lantern depth and contour. I accent the contours of the lantern by using a ¾" chisel-edged brush dipped in clear water to lift out highlights in the glass area and on the edges of the metal sides and base. I work on each area individually, blotting each area with a dry paper towel after applying the water. I use a pointed sable brush loaded with a mixture of Prussian blue and Van Dyke brown to add details such as the handles, wires, and screws to the lantern. I also use a pointed sable brush to add shadows beneath the screws and lantern top with a very dark mixture of Prussian blue and Van Dyke brown.

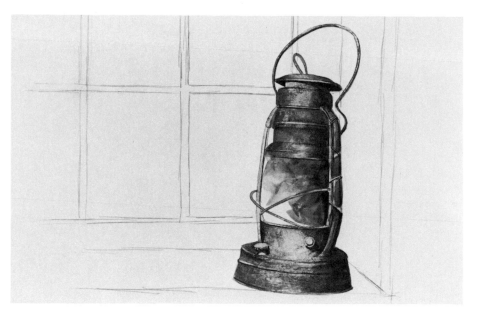

STEP FOUR. I apply thin strips of masking tape to the wooden strips dividing the windowpanes. Then, using a stiff-bristle brush, I surface-mix olive green and burnt sienna for the grass. Next, I use the wet-in-wet technique for the sky, first moistening the area and then painting in a highly diluted wash of Winsor blue with a ¾" chisel-edged brush. While the area is still wet, I add Davy's gray with the same brush and tilt the board slightly to float the colors around a bit. I paint the interior wood with a heavily pigmented mixture of Prussian blue and Van Dyke brown in a ¾" chisel-edged brush. Then I dilute the same mixture on the palette and lay in the shadows cast by the lantern and window with a ¼" (6 mm) chisel-edged brush. Finally, I remove the masking tape and paint the exposed wood with the ¾" chisel-edged brush and a thin mixture of Davy's gray, adding details with Van Dyke brown in a pointed sable brush.

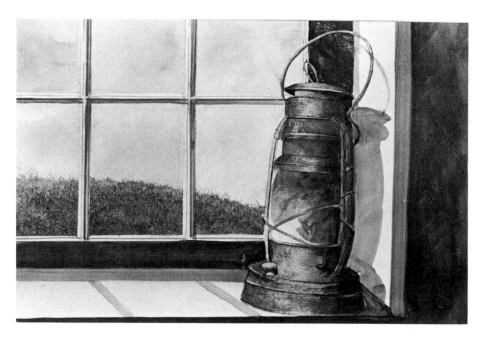

PENCIL-UNDER-WASH

Subjects with heavy textures are often represented by using the pencil-under-wash technique. The success of the technique is based on the fact that even though the pigment washes away much of the graphite, enough of the pencil underdrawing is left to show through in the finished painting.

You can use your entire range of pencils to create various effects. The softer pencils, such as a 6B or 4B, have a tendency to smudge, and some of the graphite will float away when the wash is applied—which leaves a soft, more diffused drawing beneath the wash. The medium and hard leads, from HB to 6H, create harder, more defined lines which do not wash away. Both extremes are useful in certain cases. Pencil under wash, therefore, combines the boldness of drawing with the delicacy of watercolor. Pencil, as an integral part of the painting, adds realism and emphasis.

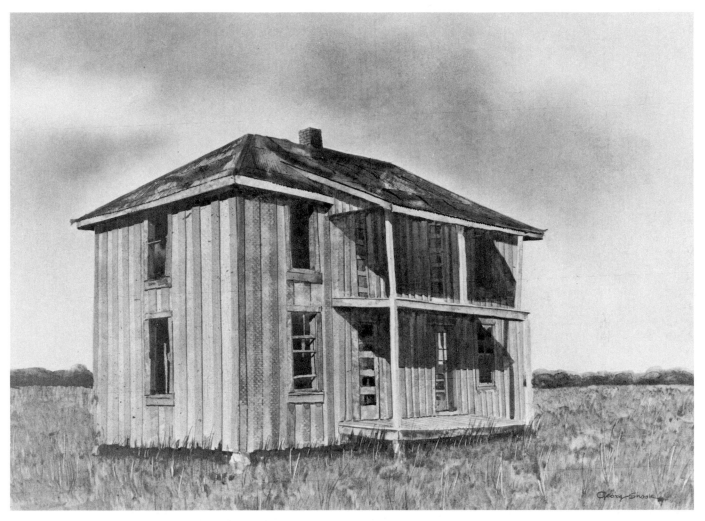

WHATEVER HAPPENED TO PARITY? 26" × 17" (66 × 43 cm). Floodwaters used to cover the Arkansas land each year, and the sharecropper family that lived on the first floor of cottages such as this one would join their neighbors upstairs until the waters receded. I used the pencil-under-wash technique to make a fairly complete drawing of the house, bringing out the strong verticals of the clapboard siding and some of the roof details. By calling attention to the house, I wanted to capture the sense of isolation the families must have experienced during a flood.

STEP ONE. I begin with a thoroughly detailed drawing of a basket, using a 4B pencil. A soft-lead pencil, such as a 2B, 4B, or 6B, is desirable here so that after the wash is applied and much of the graphite is washed away, a delicate but distinct drawing will still remain.

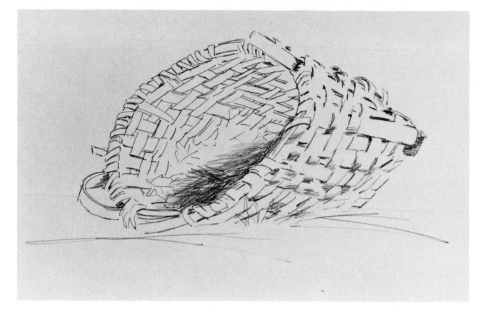

STEP TWO. Now I apply an underwash of yellow ochre and raw sienna to the basket with a ¾" (19 mm) chisel-edged sable brush. Then I blot the area with a· wet paper towel for texture. Having made sure the pigment is dilute enough to preserve the pencil detail underneath, I add shadows to the inside of the basket and under it, using Van Dyke brown and Prussian blue in a ¾" chisel-edged brush. I make the shadows inside the basket a little cooler by increasing the Prussian blue in the mixture and applying a second wash.

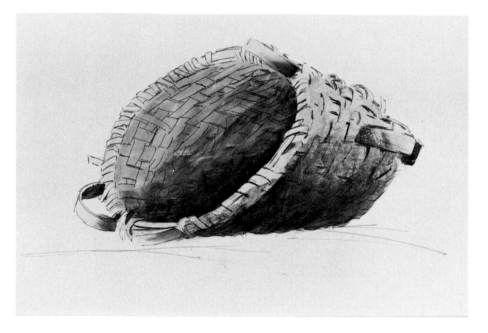

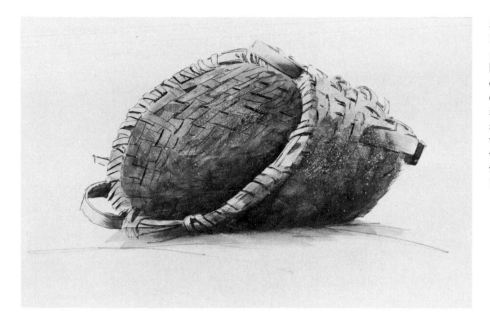

STEP THREE. Next, I add brush detailing to emphasize the contour of the rim, the handles, and the plaiting of the basket. This is done with a highly concentrated mixture of Van Dyke brown and Prussian blue in a pointed red sable brush. I then clean and use the same brush to highlight the basket by wetting certain areas and lifting them with a dry paper towel. I employ negative spattering to lend a weatherbeaten look to the basket.

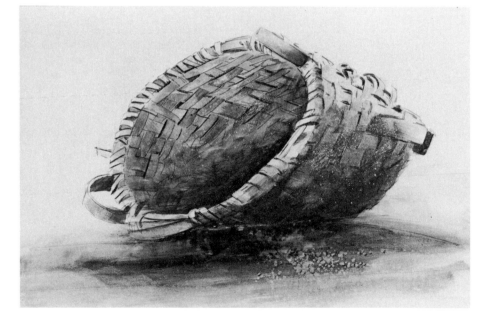

STEP FOUR. I add further detail on the plaiting of the basket with a mixture of Van Dyke brown and Prussian blue in a pointed sable brush. Then I use a ¾" chisel-edged brush loaded with a heavy mixture of Prussian blue and Van Dyke brown to accent the shadow area beneath the basket. I add a final touch by first allowing the shadow area to dry and then negative spattering it with clear water.

COLOR DEMONSTRATIONS

The subjects I have chosen for these demonstrations have wide appeal because they are subjects we all recognize from the world around us, and they speak of feelings with which we all can identify. Granted that there are no people in them, all these paintings nevertheless reveal the evidence of man. Some, like *Bushel of Apples* and *Wicker*, speak of the commonplace in our lives; while others, such as *The Other Window* and *Attic*, contain a human mystery—even if a small, everyday one. I want these paintings to reflect the quiet strength of places and things we all know but don't notice, and I paint such scenes with the hope that we will begin to notice now.

Of course, these subjects have also been chosen for the technical problems they pose for working on hot-pressed surfaces. Problems of texture, light and transparent shadows, light as a form-creating subject itself, reflections on glass and water, and intricate detail—all these challenges we will face in the eight paintings that follow. The stage has been set by the previous section of short demonstrations, and all the techniques explained there will be put to good use here. In fact, I have tried to incorporate as many techniques as possible into each of these paintings to show the versatility of each procedure.

All the demonstrations will be done on Strathmore Hi Plate Illustration Board, either 20″ × 30″ (51 × 76 cm) or 30″ × 40″ (76 × 101 cm), laid flat on my horizontal easel. Again, my palette will be limited to a few colors for each painting, since I can get a wide enough tonal range by mixing the various colors together. Besides, you don't need as many colors on hot-pressed board as on absorbent paper because the color remains right on the surface and is therefore more dense and brilliant. Another good reason for limiting the palette to a few colors is that too many colors can be confusing, especially to the beginner. By the same token, I don't need many brushes. A brush is more versatile than you might think. For instance, I can get a razor-sharp line or a broad stroke merely by adjusting the angle of my ¾″ (19 mm) chisel-edged brush. You should always use good brushes, since they perform so much better and last longer. You can, however, keep a few cheaper ones around for operations in which the brush takes a lot of abuse.

I should point out that the order of steps that will be taken in each painting is not the only order you can follow, or even the best one. With hot-pressed surfaces, you can work whatever area of the board you choose, to whatever degree you wish. For instance, in *Low Tide* I will complete an entire portion of the board first to establish the value scale for the rest of the painting. Unlike the more absorbent papers, you don't have to work from dark to light or from background to foreground. So use my demonstrations as one artist's example, but try your own hand at painting your favorite scene on the hot-pressed surface. And above all, enjoy!

DACUS LAKE BOAT DOCK

I came upon this scene while exploring in Arkansas one Sunday morning, and I knew immediately that I had to paint it. There was a certain mood about the still water and the apparent vacancy of the dock that I liked, and the brilliant reflective quality of the water made the subject ideal for the hot-pressed surface. I made several sketches and reference photographs before I returned to my studio to begin work.

Dacus Lake Boat Dock will be done on Strathmore Hi Plate Illustration Board 240-2, 30″ × 20″ (76 × 51 cm). My palette will consist of Winsor blue, Davy's gray, olive green, burnt sienna, cadmium red, Van Dyke brown, and Prussian blue.

STEP ONE. I make a fairly detailed preliminary sketch, using a 2B pencil. The advantage of using a soft lead on the hot-pressed surface is that even though some of the graphite washes off during the actual painting, it leaves a faint image which becomes an integral part of the finished work. I now place masking tape over the roof of the building where it extends into the sky area. I often use the resist technique since it helps keep areas of the board dry and free from paint. I now sponge clear water over the entire sky area, and then I pick up some Winsor blue on the sponge and squeeze it onto the board. I float the pigment into place by slowly tilting the board in various directions. Now I use the same sponge to repeat the process, only this time with Davy's gray.

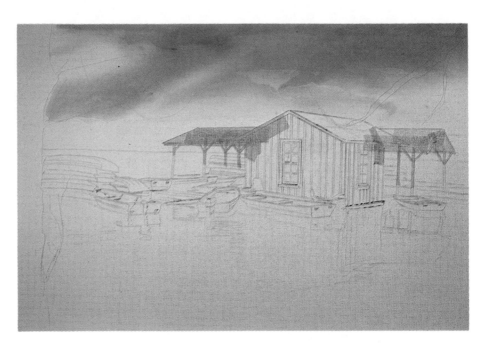

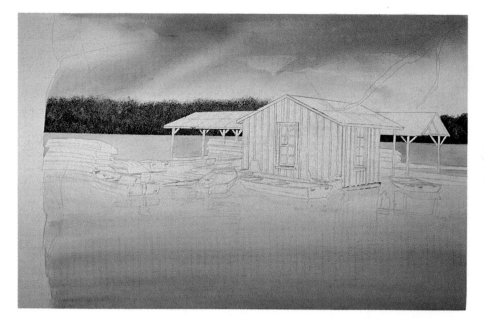

STEP TWO. Leaving the masking tape in place, I use a sponge to pick up a mixture of olive green and burnt sienna and then dab in the trees on the distant bank. Using a ¾" (19 mm) chisel-edged brush loaded with Winsor blue and a bit of Davy's gray, I paint in the water with broad, horizontal strokes. I try to be spontaneous here, letting some of the white board show through to preserve the shimmer of light that appears on the surface of a lake. Now I carefully remove the masking tape.

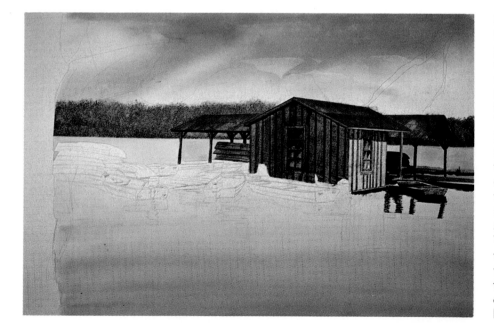

STEP THREE. At this stage I need to establish some of the darks within the painting, and so I begin work on the structure and the shadows beneath the open roof. I paint the roof using a ¾" chisel-edged brush loaded with a mixture of burnt sienna and Winsor blue. Then, because the window reflects the light from the water's surface, I paint it using the same Winsor blue that I used to paint the water, and I add a small amount of burnt sienna. Now I block in the wooden area of the boat dock, using a mixture of Davy's gray with small amounts of burnt sienna and Winsor blue. Then I blot the area with a wet paper towel to give the wood a weathered texture. I also paint some of the boats and accent the shadow areas and water reflections with Van Dyke brown and Prussian blue.

STEP FOUR. I paint the rest of the boats with a mixture of Davy's gray and Winsor blue with some burnt sienna. Then I add a little cadmium red to the first boat on the left, which serves as a point of entry and creates a "hot spot" that plays against the cooler temperature of the surrounding blues.

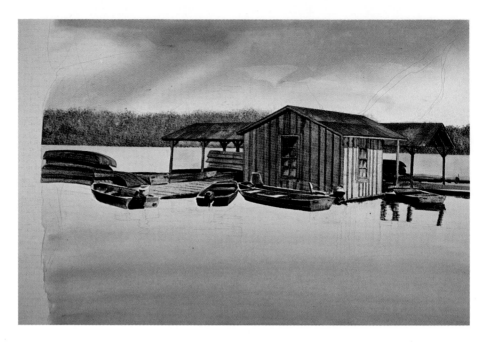

STEP FIVE. Now I need to complete the darkest darks, since the painting has mainly light and middle tones and lacks contrast. I begin to add dark tones by using Van Dyke brown and Prussian blue in a ¼" (6 mm) chisel-edged brush to fill in the shadows of the boats and the building in the water. Then I use the same mixture to paint in the reflections of the building and boats within the shadows. Because the sunlit side of the building is warmer in tone than the shadow side, its reflection in the water should also appear warmer. So I pull a diluted wash of burnt sienna across the reflection with a ¾" chisel-edged brush. Then, to give the area a more fluid look, I dip the tip of the brush in clear water and carefully lift out some of the pigment to get back some of the blue underneath. I also blur the edges of the reflections by pulling the water-loaded brush outward across those edges, literally moving the pigment to give the area a sense of motion.

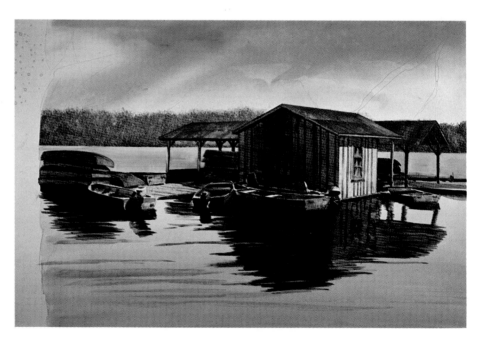

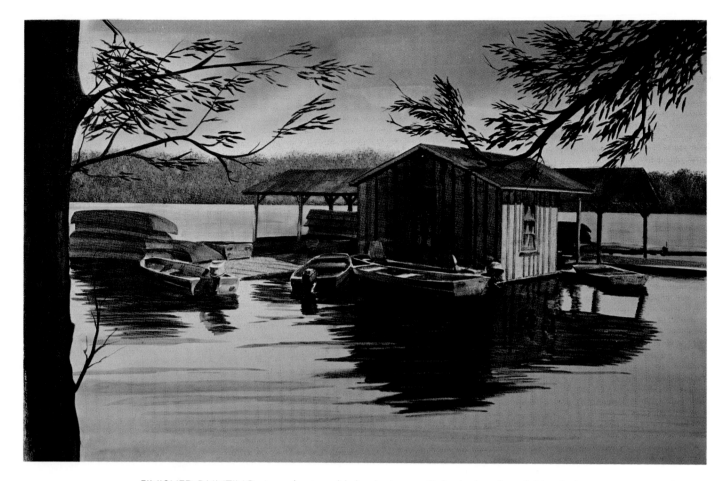

FINISHED PAINTING. In order to add depth, I use a Kolinsky brush with Van Dyke brown and Prussian blue to paint a branch across the upper right-hand portion of the painting. Then, with a ¾" chisel-edged brush loaded with burnt sienna and Van Dyke brown, I block in a tree trunk on the left-hand side of the picture and add a few branches. This compositional device gives the painting the perspective I want. Finally, I finish the piece by adding more detail to the tree trunk, using a Kolinsky brush loaded with Van Dyke brown and Prussian blue.

THE ATTIC

My fascination with remnants from the past has always led me to explore old attics. Recently I was allowed to browse through one in an old Virginia home, where I photographed this scene. I especially liked the effect of the window here, which let in light but nothing else from the modern world.

The Attic will be painted on Strathmore Hi Plate Illustration Board, 20″ × 30″ (50 × 76 cm) and my palette will consist of Prussian blue, Van Dyke brown, Winsor blue, burnt sienna, raw sienna, cerulean blue, cadmium red, and raw umber.

STEP ONE. After completing the pencil drawing with a 2B pencil, I establish the darkest dark by laying in a heavily pigmented mixture of Prussian blue and Van Dyke brown on the wall, using a ¾″ (19 mm) chisel-edged brush. Then, because it is very important to maintain a balance of color temperature—that is, to play cool colors against warm colors—I lay in some burnt sienna to interplay with the coolness of the Prussian blue. This balancing is especially needed in dark shadow areas. Next I use a ¼″ (6 mm) chisel-edged brush with the Prussian blue and Van Dyke brown mixture to paint the window framework, which is in heavy shadow. I now apply a dilute wash of Winsor blue and burnt sienna to the window itself. This warmer tone gives the glass the diffused, translucent effect I am seeking.

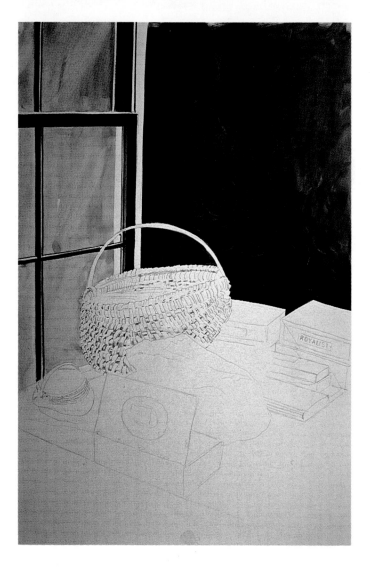

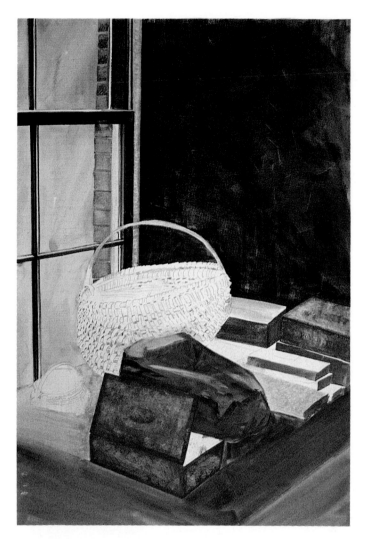 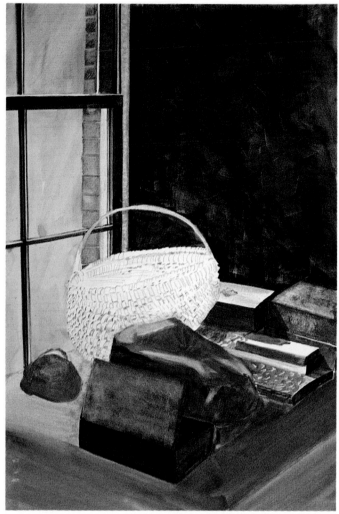

STEP TWO. Now I use a ½″ (13 mm) chisel-edged brush to block in the tabletop and cigar boxes with a very diluted burnt umber. Then I use the same brush loaded with raw sienna and burnt sienna to paint in the form of the foreground cigar box, which I edge with pure burnt sienna in a ¼″ chisel-edged brush. Raw sienna and a small amount of burnt sienna are used to build up the form of the cigar boxes in the background. I paint the paper bag with a mixture of raw umber and Winsor blue in a ¾″ chisel-edged brush. To model the bag, I add more Winsor blue to the mixture and paint its shadows and creases. Then I paint the brickwork outside the window with a mixture of Winsor blue, burnt sienna, and Van Dyke brown in a ¾″ chisel-edged brush. Finally, I notice that the wall seems too active or busy; so I soften the brushstrokes with a ¾″ chisel-edged brush dipped in clear water, and I darken the lower corner with an over-wash of Prussian blue.

STEP THREE. At this stage, I develop the details and shadows on the boxes and bag, and I fill in the shadow on the foreground cigar box, using a mixture of Van Dyke brown and Prussian blue in a ½″ chisel-edged brush. Then, with the same mixture in a ¾″ chisel-edged brush, I create shadows on the bag and boxes in the background. I paint the basket-weave pattern on the books by applying cross-strokes with a ¼″ chisel-edged brush, using a dilute mixture of the Prussian blue and Van Dyke brown. Finally, I block in the small basket on the left using raw sienna and burnt sienna in a ¼″ chisel-edged brush.

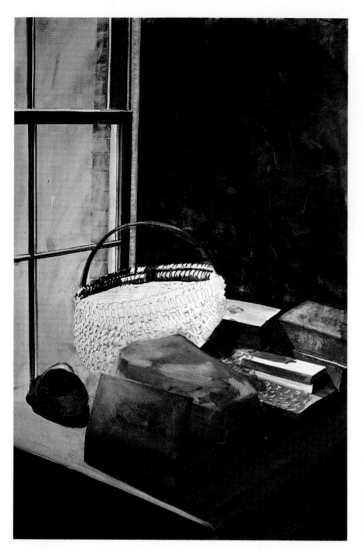

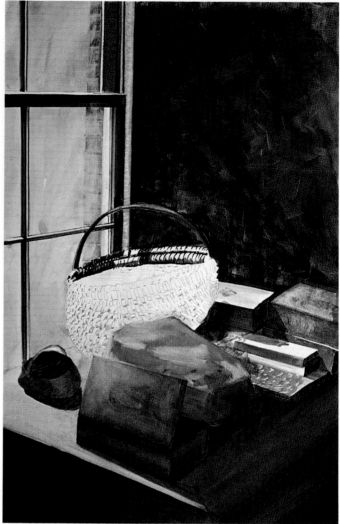

STEP FOUR. Now I develop the shadows on the table and table edge by laying down a wash of Prussian blue and Van Dyke brown with a ¾″ chisel-edged brush. Then I use the same brush dipped in clear water to lift some highlights from the sunlit areas of the table. I further develop the deep shadow of the foreground cigar box and add density inside the box with Van Dyke brown. I treat the small basket on the left in the same manner. To further model the box, I lift some of the color from the edge to reflect the sun from the table. Now I notice that the bricks outside the window seem too well defined, and so I lighten them with a sponge dipped in clear water and then blot the area dry. Now I turn to the large basket, painting the handle with Van Dyke brown and Prussian blue in a pointed red sable brush. I use the same mixture to develop some of the shadow work on the basket.

STEP FIVE. I add contrast to the shadow area by lifting some color from the left side of the tabletop with a sponge and clear water. Then I add a shadow overwash along the edge of the table with a ¾″ chisel-edged brush loaded with Van Dyke brown and Prussian blue. At this point I also use the dark mixture to deepen the shadows along the stacked boxes in the background.

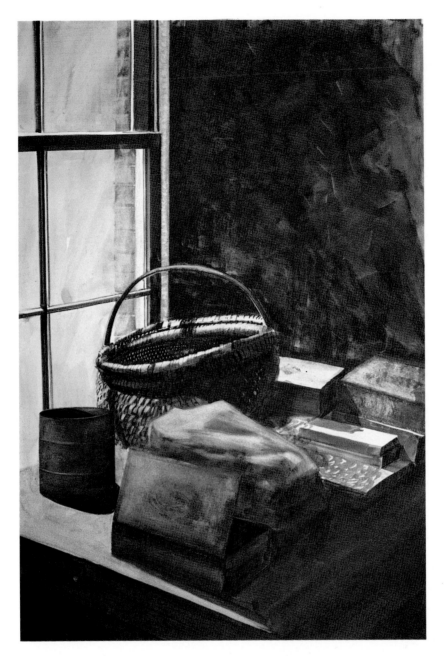

FINISHED PAINTING. Now I notice that the relationship between the two baskets is confusing: with both being the same style of basket, I feel that the smaller basket looks like a miniature version of the larger basket and that it detracts from, rather than adds to, the composition. So I decide to replace the smaller basket with a tin can. Being able to make such a change is the real advantage of the hot-pressed surface. I wet the smaller basket with a brush dipped in clear water, and then I blot the area with a dry paper towel—lifting the pigment out and leaving a pure white surface. Then I paint in the tin can, first blocking it in with burnt sienna and Winsor blue and then adding shadows with a mixture of Van Dyke brown and Prussian blue. Now, using the same ¾" chisel-edged brush, which I wet in clear water, I lift out the seams of the tin can. I use a pointed red sable brush to add detailing to the larger basket with a mixture of burnt sienna, Prussian blue, and Van Dyke brown. Then I use the same brush, now rinsed and loaded with cerulean blue, to paint the top of the box in the foreground. A touch of cadmium red adds some warmth to the box top. Now I lift highlights along the edges of the boxes and on top of the bag by wetting these areas with a chisel-edged brush dipped in clear water and blotting with a dry paper towel. I use the same procedure to lift highlights from the upper rim of the large basket. Finally, I add detail to the window frame with a Kolinsky brush loaded with a mixture of Prussian blue and Van Dyke brown.

WICKER

There were several things about this porch scene that caught my attention when I first saw it: the beautiful contrast in textures between the wicker and the weathered wood, the patterns of light and shadow created by the afternoon sun, and the way the rear window suggested space and light beyond the structure itself. These qualities should inspire the imagination of any artist. *Wicker* will be done on Strathmore Hi Plate Illustration Board, 30″ × 20″ (76 × 50 cm), and my palette will consist of Davy's gray, burnt sienna, Prussian blue, Van Dyke brown, and Winsor blue.

STEP ONE. I use a 2B pencil to make a detailed drawing of the scene. Next, I brush on some Maskoid, a liquid resist material, to the areas of the chair that I want to be highlighted in the finished painting. I block in the wall area with a ¾″ (19 mm) chisel-edged brush loaded with Davy's gray and burnt sienna. I use random strokes on the wall, and then I immediately blot the entire area with a wet paper towel to give it texture. Next, I use a heavy mixture of Prussian blue and Van Dyke brown in a ¾″ chisel-edged brush to paint the interior around the window in the rear. Then I paint the rear window itself by wetting the area and floating in a diluted wash of Winsor blue.

STEP TWO. I use a ¾" chisel-edged brush to apply a mixture of Davy's gray, burnt sienna, and Winsor blue to the exterior wall and then blot it immediately with a wet paper towel. I apply a second layer of the same mixture and blot it also. This increases color density and adds depth to the textured wood.

STEP THREE. I load a ¼" (6 mm) chisel-edged brush with a heavy concentration of Davy's gray and add vertical shadows to the wall. Then, using the same brush, I pick up a mixture of burnt sienna and Winsor blue and go over the same shadows with long, vertical strokes, using the Davy's gray as an undertone. I now brush a lighter mixture of Davy's gray, burnt sienna, and Prussian blue onto the floor area with a ¾" chisel-edged brush, and I add a highlight of burnt sienna on the left with the same brush. Then I paint in the diagonal shadow area under the porch with a mixture of Van Dyke brown and Prussian blue.

STEP FOUR. I add a shadow to the scene, drawing attention to the corner where the chairs are situated, with a diluted mixture of Van Dyke brown and Prussian blue in a ¾″ chisel-edged brush. This overwash must be applied carefully in uninterrupted strokes, or the color underneath will be lifted out. I lift some highlights from the front edges of the floorboards with a pointed brush dipped in clear water. This area must be blotted with a dry paper towel to actually remove the pigment. The lifting was needed to soften the contrast between the sunlit floorboards and the dark shadow underneath. Now I use a ¾″ chisel-edged brush to paint each board of the wall and floor individually—some with Davy's gray, others with burnt sienna, and still others with Prussian blue. These overwashes represent the colorful hues seen in weathered wood.

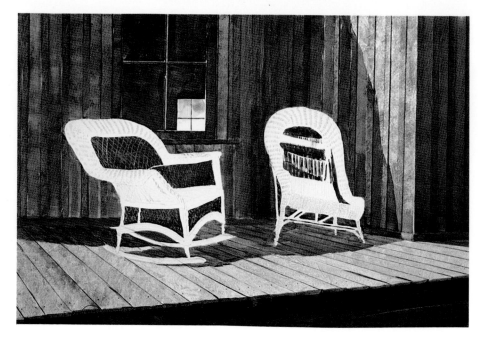

STEP FIVE. I remove the Maskoid on the chairs by rubbing my fingers over the surface. The dried, rubbery film rolls right off the slick surface of the Hi Plate board. Then I use a ¼″ chisel-edged brush to paint a wash of raw sienna mixed with lesser amounts of burnt sienna and Winsor blue over the chairs. I use the same brush to add Winsor blue detailing to the chairs so their coolness will balance the warmer burnt sienna of the floor.

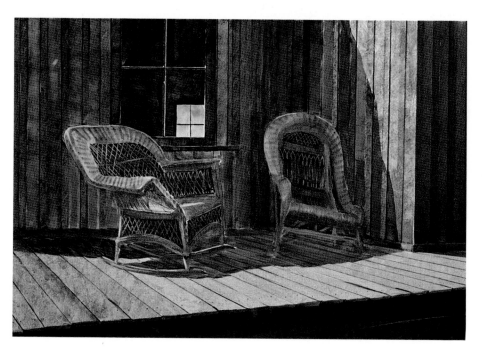

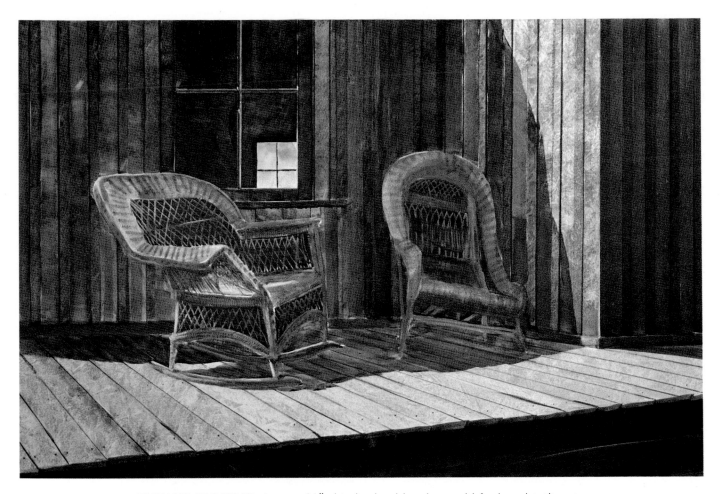

FINISHED PAINTING. I use a ¼″ chisel-edged brush to add further detailing to the siding of the house and to wash an additional shadow, with a Prussian blue and Van Dyke brown mixture, over the chair on the right. Then I increase the Prussian blue in the mixture and use a ½″ (13 mm) chisel-edged brush to pull this cooler overwash across the floor beneath the chairs. With Van Dyke brown in a ¼″ chisel-edged brush, I add detail to the sunlit area of the floor. Then I lift color from the front edge of the floor with a ¾″ chisel-edged brush dipped in clear water. For a final touch, I add rusty nails with a pointed sable brush loaded with pure burnt sienna.

THE OTHER WINDOW

A room seen through a window has always held great mystery for me, possibly because reflections from the windowpanes blur the interior details, giving the room a soft, dream-like quality. It is a challenge to paint such a scene, however, because two focal planes are involved. In *The Other Window* the first focal plane is the front wall and window, and the second is the interior of the room with another window on the far side. The difficulty is that the second focal plane is seen through the first and must be rendered softly if the illusion of depth and mystery is to be effective. I will use Winsor blue, Davy's gray, burnt sienna, Van Dyke brown, and Prussian blue for this painting, which will be done on Strathmore Hi Plate Illustration Board, 20″ × 30″ (50 × 76 cm). The advantage of the hot-pressed surface here is that the brilliant, reflective quality of the glass can be captured by lifting out colors for highlights.

STEP ONE. On the Hi Plate board I make a preliminary pencil drawing with an HB pencil. Then I apply masking tape to the window frame and cut thinner strips of tape which I place over the dividers between the individual panes of glass. Now I lay in a light wash of diluted Winsor blue over most of the window area with a ¾″ (19 mm) chisel-edged brush. Notice that I carefully paint around the rear window frame, since Winsor blue is a staining color and cannot be lifted out very well. Next, I block in the rear windowpanes with a ¼″ (6 mm) chisel-edged brush, making them darker than the front panes with a mixture of Prussian blue and Davy's gray.

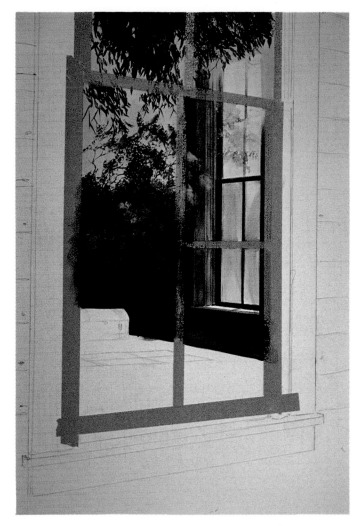

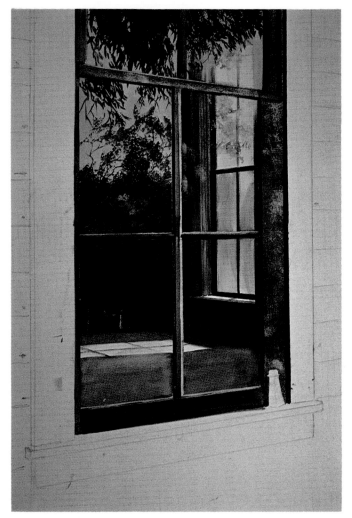

STEP TWO. Now I establish the darkest darks in the painting by blocking in the shadows on the rear wall and by painting in the reflections of foliage on the front glass, again being careful not to paint over the rear window frame. I use a Kolinsky brush loaded with a mixture of Van Dyke brown and Prussian blue for both procedures. Now I fill in the rear window using ¼" chisel-edged brush loaded with Van Dyke brown, burnt sienna, and Winsor blue. I add detail lines with a Kolinsky brush loaded with Van Dyke brown and Prussian blue.

STEP THREE. I remove the masking tape and block in the front window frame and dividers using a mixture of Davy's gray, burnt sienna, and Winsor blue in a ¾" chisel-edged brush. Then I lift highlights from the frame with a Kolinsky brush dipped in clear water, and I add shadows with the same brush loaded with Van Dyke brown and Prussian blue. I now use a ¾" chisel-edged brush loaded with a dilute mixture of Van Dyke brown and Prussian blue to paint the floor of the room, being careful to paint around the area where the sunlight is falling through the window. I add the trunk in the far corner of the room using a Kolinsky brush loaded with burnt sienna, and then I incise the detailing with the end of the wooden brush handle.

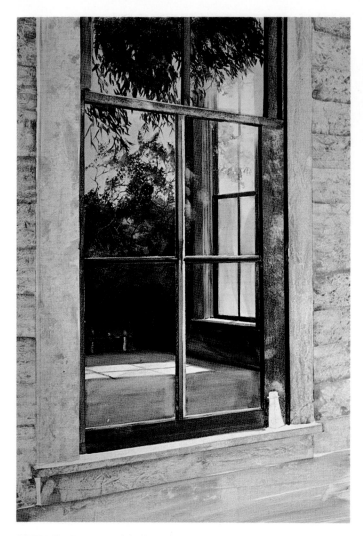

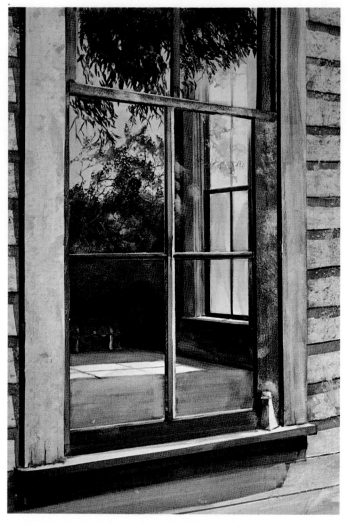

STEP FOUR. Here I block in the exterior front wall with Davy's gray in a ¾" chisel-edged brush and blot it with a wet paper towel. Now I use the same brush to pull a dilute burnt sienna overwash across some boards and a dilute Winsor blue overwash across others. This helps to balance the color temperature: a cool interior, a warm trunk, and an outer wall that blends the two. While the pigment is still wet, I blot the front wall again with a wet paper towel to complete the illusion of weathered wood. Finally, I add detailing and deep shadows to the far window and front wall with a Kolinsky brush loaded with Prussian blue and Van Dyke brown.

STEP FIVE. Next, I use a ¼" chisel-edged brush to add shadows to the clapboard siding and lower edge of the front window and to further develop details in the window frame, using a mixture of Prussian blue and Van Dyke brown. Then I flick clear water onto the clapboard siding and quickly wipe the surface with a dry paper towel. This lifts the pigment to create a low white relief, lending additional texture to the wood.

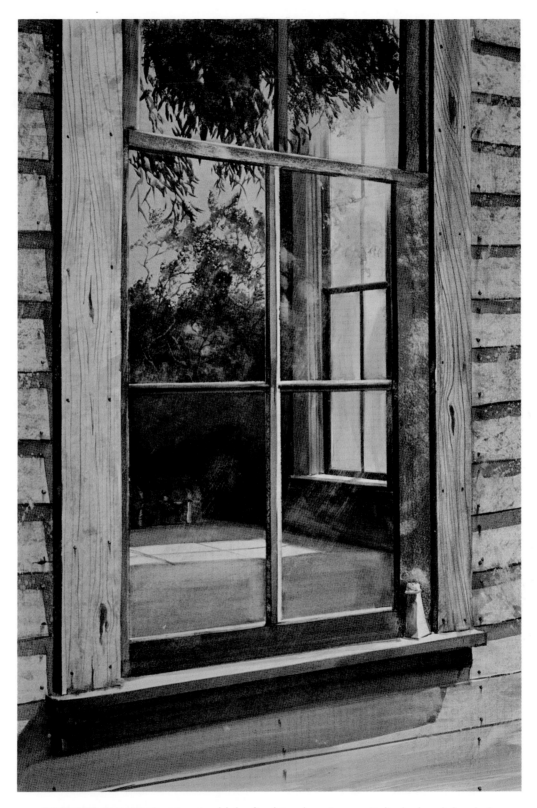

FINISHED PAINTING. Now I add the final touches. I use a Kolinsky brush loaded with burnt sienna to detail the wood graining on the window frame, and then I dab the same pointed brush along the siding to indicate nails. To get the shimmer of sunlight on glass, I lift highlights from the window with the edge of a ¾" chisel-edged brush dipped in clear water and blot the area dry. I use the same brush loaded with Prussian blue and Van Dyke brown to further develop the shadows on the siding. Finally, I use a Kolinsky brush to strengthen the reflections on the front window with a mixture of Prussian blue and Van Dyke brown.

WHITE PILLARS

A stately mansion once stood on this site in La Grange, Tennessee, but all that is left today is a rutted track which appears to wander aimlessly between the white columns. *White Pillars* is my attempt to recall the poignant feeling which this scene evoked in me as I sketched it one summer's day. The Strathmore Hi Plate Illustration Board, 30″ × 20″ (76 × 50 cm), allows me to preserve the whiteness of the columns, as well as to create the surface textures of the grass and road. My palette will be olive green, Davy's gray, burnt sienna, Van Dyke brown, Prussian blue, and Winsor blue.

STEP ONE. After making a pencil drawing with a 2B pencil, I place masking tape over the picket fence and pillars to prevent them from being stained while I paint the sky, trees, and grass. It is especially important to protect white areas while surface color mixing occurs, since the stiff-bristle brush actually gouges the surface of the board. Once paint gets into the fibres beneath the slick surface, it is nearly impossible to lift out the color again.

STEP TWO. I wet the sky area with a sponge and clear water, and then I use a 1" (25 mm) chisel-edged brush to apply a flat wash of Winsor blue in broad, horizontal strokes. After the wash has dried, I sponge in the distant tree line with olive green. To build up this area, I sponge over it again with a mixture of Prussian blue and Van Dyke brown. This second application accents the color and deepens the shadows, but seeing more warmth is needed, I sponge the area yet again with burnt sienna.

STEP THREE. I use a sponge loaded with olive green to develop a tree in the middle foreground. As this olive green underpainting dries, I deepen the shadows within the foliage by sponging the area a second time with mixture of Prussian blue and Van Dyke brown. I then use the same sponge and color mixture to add another tree to the left side of the board, dabbing carefully to suggest the texture of leaves.

STEP FOUR. Using a ¾″ (19 mm) stiff-bristled oil painting brush, I pick up a heavy load of olive green and apply it to the foreground area. Then I rinse the brush and repeat the process using burnt sienna. I then mix these pigments on the surface of the board, using the stiff-bristle brush to suggest the texture of grass. I notice that the color of the trees on the horizon is a bit too deep, and so I lighten it by lifting out some of the color with a sponge and clear water. I surface-mix Prussian blue and Van Dyke brown to create the shadow of the tree on the right. Then I create the parallel tracks by using a sponge and clear water to lift paint—wiping in a single motion for each track. I paint in the tracks using the drybrush technique: I wipe a ¾″ chisel-edged brush dry and then load it with burnt sienna. The dry brush drags over the surface, leaving a unique textural effect. Now I can remove the masking tape from the pickets and pillars.

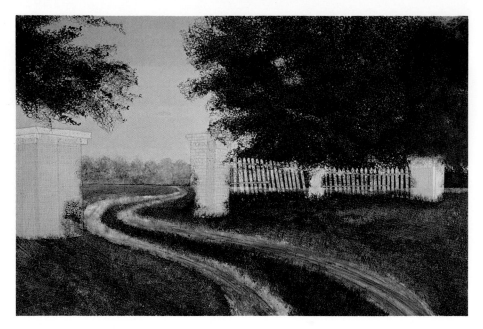

STEP FIVE. I use a pointed Kolinsky brush loaded with a mixture of burnt sienna and Winsor blue to paint in the tree trunks and branches. I stipple in the shadow cast by the tree on the left with a stiff-bristle brush loaded with a mixture of Prussian blue and Van Dyke brown. Now I use the same mixture to accentuate the tracks in the foreground, first by removing excess moisture from the brush and then by using the drybrush technique.

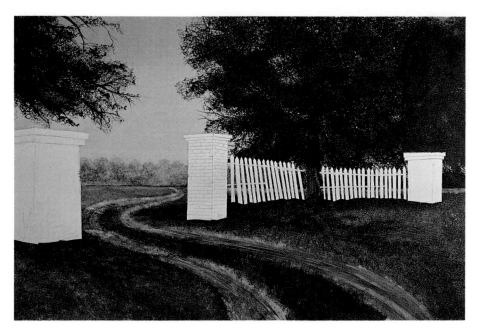

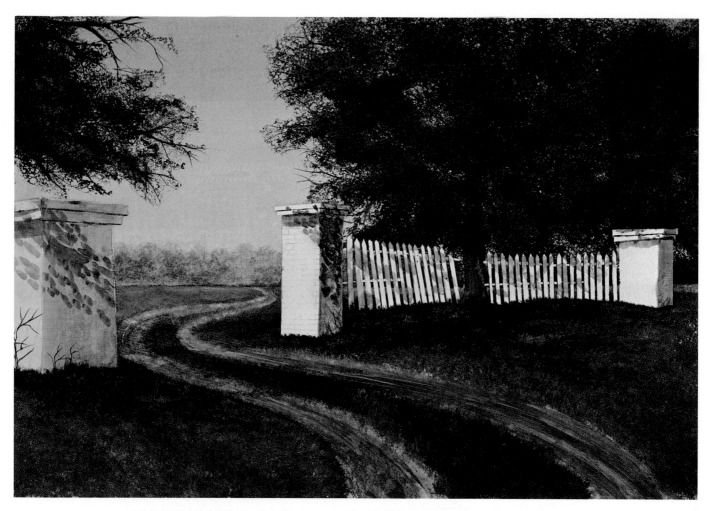

FINISHED PAINTING. Finally, I create the shadows on the pickets and pillars by using a very diluted mixture of Van Dyke brown and Prussian blue on the chisel edge of a ½″ (13 mm) brush. I use the same brush and mixture to emphasize the shadows beneath the trees and foliage. I finish the painting by adding more branches using a dagger striper brush with burnt sienna and Winsor blue and by strengthening the shadows which fall across the road with a stiff-bristle brush loaded with Prussian blue and Van Dyke brown.

BUSHEL OF APPLES

One of the many charms of the rural South is its simplicity. For instance, a farmer who wishes to sell his produce often parks his truck beside the road and just sets his baskets of fruit and vegetables out on the tailgate. If he wishes a more elaborate display, he may even build a wooden stand such as the one here, which I encountered recently in Middle Tennessee. After a short conversation with the owner (and a modest purchase of apples), I made a variety of sketches and took several photographs. Since I was not sure what treatment I wanted to give this quaint scene, my preliminary sketches were more extensive than usual.

I decided how to treat the scene back in the studio, and *Bushel of Apples* is the result. It will be done on Strathmore Hi Plate Illustration Board, 20″ × 30″ (50 × 76 cm), with a palette more varied than usual. I will use raw umber, raw sienna, burnt sienna, Van Dyke brown, cadmium yellow, cadmium red, yellow ochre, olive green, and Winsor blue.

STEP ONE. I decide to paint a fairly close-up scene with emphasis on a single bushel basket. I begin by making a detailed drawing with a 2B pencil, using one of the reference photographs as a guide. Now I paint in the background to establish the darkest dark of the picture's tonal range. I load a ¾″ (19 mm) chisel-edged brush with a mixture of Prussian blue and Van Dyke brown, and I quickly block in the wall, picking up a small amount of burnt sienna now and then to add interest to an otherwise muted tone.

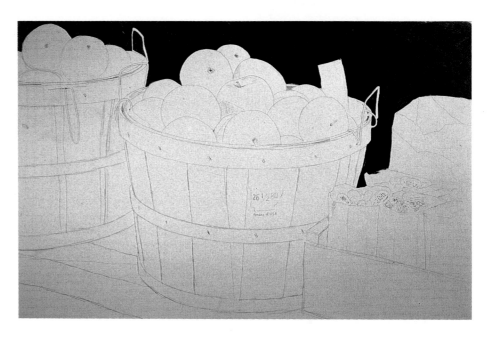

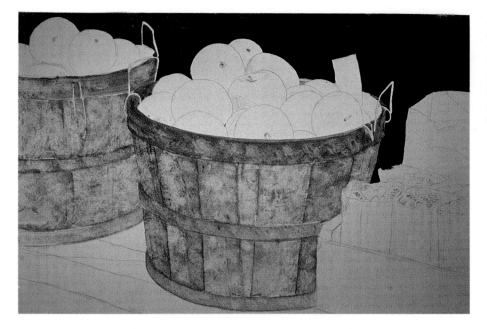

STEP TWO. I use the same chisel-edged brush loaded with a mixture of yellow ochre and a smaller amount of burnt sienna to block in the two baskets. While the pigment is still wet, I blot the area with a wet paper towel to establish the underlying texture of wood.

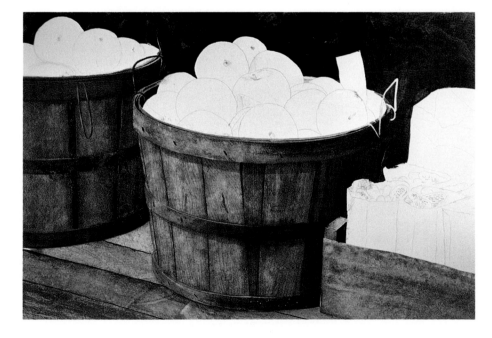

STEP THREE. Using a ¾" chisel-edged brush, I block in the wooden shelf with a mixture of raw umber and yellow ochre. Then I use the same brush, thoroughly cleaned, to add shadow and contour to both baskets with a wash of Winsor blue and burnt sienna. A pointed sable brush loaded with burnt sienna is used to add detailing to the shelf and both baskets, as well as to paint the bands around both baskets. I also paint the box on the right, using yellow ochre mixed with a small amount of burnt sienna in a ¾" chisel-edged brush.

STEP FOUR. I use a mixture of raw sienna and raw umber in a ¾″ chisel-edged brush to paint the peanut bags and the sack behind the box. I change to a pointed sable brush and use the same mixture to loosely block in the peanuts themselves.

Now I am ready to develop the apples in the rear basket. I want to reduce the emphasis on this basket of apples, and so I paint the apples green instead of their actual red color. The real point of interest is the basket of apples in the center, and I don't want anything else to compete with it for the viewer's initial attention. I begin by underpainting the apples in the rear with a dilute wash of cadmium yellow, blocking in the rough shape of each apple. Then I pick up a small amount of olive green in the ¾″ chisel-edged brush and begin to form the apples by painting over the cadmium yellow. What happens now is unique to the hot-pressed surface: the olive green rewets the cadmium yellow underneath and lifts some of it out, creating highlights of yellow against various blends of yellow and green. This is color mixing right on the surface, and the brushstrokes shape and form the apples as the mixing occurs. To finish this step, I use concentrated burnt sienna in a pointed sable brush to add accents to the wire handles and to emphasize the bands on both baskets. I then use a mixture of Prussian blue and Van Dyke brown in a ¾″ chisel-edged brush to add shadows to the paper bag, peanut sacks, and wooden box.

STEP FIVE. Now I begin to block in the apples in the center basket. I use a ¾″ chisel-edged brush loaded with cadmium yellow and make a series of fluid brushstrokes for each apple, creating its individual shape and contour. Deciding that more detail work is needed on the wood, I intensify the shadows on the rim of the center basket and deepen the cracks in the shelf with a mixture of Prussian blue and Van Dyke brown in a pointed sable brush. Then I strengthen the contrast on the paper bags and sack by lifting highlights with a ¾″ chisel-edged brush dipped in clear water and then blotting with a dry paper towel. I also lift a bit of color from the green apples.

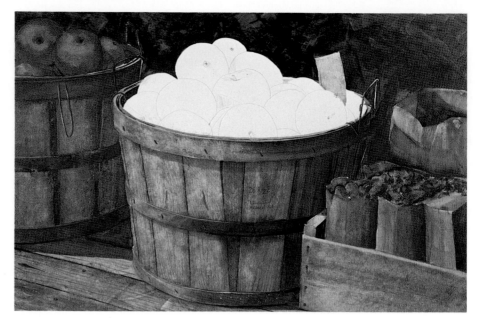

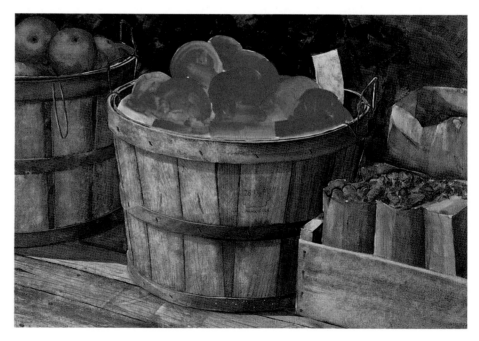

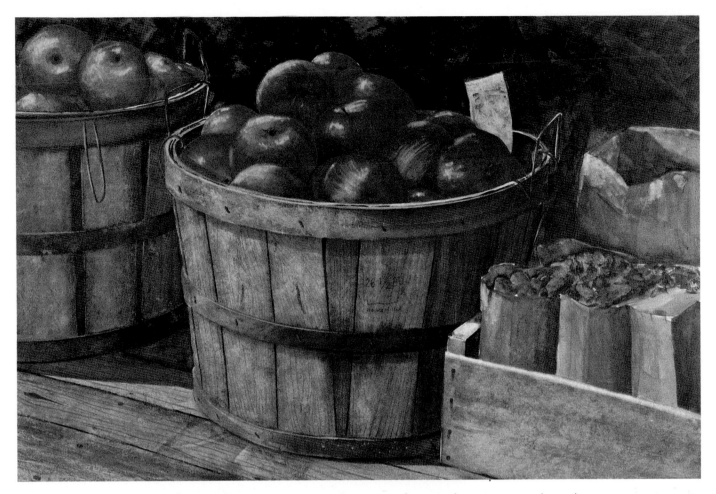

FINISHED PAINTING. Now I create the center of interest by painting each apple cadmium red with a ¾″ chisel-edged brush. Again, surface color mixing occurs, as each brushstroke picks up some of the cadmium yellow underpainting while laying down the red. This procedure, which allows the cadmium yellow to bleed through, gives mass and shape to each apple. Occasionally, I pull the brush across a damp paper towel to remove excess pigment so that each stroke with the lightly loaded brush not only lays color down but models the apple with subtle gradations of tone and occasional highlights. Finally, I make a mixture of Prussian blue, Van Dyke brown, and olive green and use a pointed sable brush to add detailing to the stems and ends of each apple. For a final touch, I use the same brush to letter in the price for this basket of apples.

LOW TIDE

One of the reasons I conduct so many workshops and painting demonstrations around the country is that I love to travel. I welcome any change of scenery because it provides me with new subjects to paint and allows me to alter my color palette to best represent the prevailing mood of each area.

Low Tide is the product of one of my trips, which went up the Eastern seaboard into Canada and Nova Scotia. The tidal basin this painting depicts was at low tide when I happened upon it, and the overturned boat seemed to evoke the mystery and loneliness of the scene. This area also challenged me as an artist: an overwash of yellow ochre seemed to cover the air, and I knew that I would have to alter my color palette to capture the deep yellow glow produced by the afternoon sun. While at the site I made a couple of preliminary sketches and took a reference photograph. Then I completed *Low Tide* in my studio using Strathmore Hi Plate Illustration Board, 40″ × 30″ (101 × 76 cm), and a palette of olive green, yellow ochre, Winsor blue, cerulean blue, burnt umber, burnt sienna, Prussian blue, and Van Dyke brown.

STEP ONE. I make a 4B pencil drawing of the scene—not extremely detailed, but complete enough to set up the formal value pattern which I want to have in the finished painting. I apply masking tape as a resist over the sloping guardrail and the houses behind it. Then I use the stiff-bristle-brush technique with barely diluted olive green pigment to stipple in the hillside, picking up a little yellow ochre for the sunlit end of the hill. I use a mixture of Prussian blue and Van Dyke brown to stipple in the shadowed sides of the hills, while the deep slopes are brushed in using a concentrated mixture of yellow ochre and a small amount of olive green.

After removing the masking tape from the houses, I use a pointed sable brush to block in their shaped sides with a dilute mixture of Prussian blue and Van Dyke brown. I leave the west sides of the houses white to suggest the brilliant glow of the setting sun. Then I load the pointed sable brush with burnt sienna and Winsor blue to paint in the roof of each house.

STEP TWO. I remove the masking tape from the guardrail, and, using a ¾" (19 mm) chisel-edged brush, I paint in the sloping rail with a very dilute mixture of burnt sienna and yellow ochre. I use the same brush, thoroughly cleaned with water and loaded with a mixture of Van Dyke brown and Prussian blue, to paint in the shadowed sides of the posts. Now I use a ¾" chisel-edged brush to block in the seawall with a highly diluted undertoning of yellow ochre. I use the same brush to block in the tidal basin area with a mixture of burnt umber and yellow ochre, carefully painting around the sketched-in tidal pools to leave them pure white. Though I use the sketch as a guide, I try to be spontaneous enough to capture the irregular shapes of land and water.

STEP THREE. At this stage I concentrate on the foreground, which is the point of entry into the painting and the real center of interest. I surface-mix Prussian blue and Van Dyke brown with a stiff-bristle brush, and I then use the sponge technique to create the impression of weeds in front of the boat. I give a soft, flowered look to some weeds running along the left side of the boat by using a type of lift technique: I flick water onto the surface at a sharp angle, allowing it to set for a few seconds, and I then briskly wipe the water away with a dry paper towel. This lifts some of the pigment but leaves a diffused hue. To complete this step, I brush in the water areas with a very dilute wash of cerulean blue, using a ½" (13 mm) chisel-edged brush.

STEP FOUR. Now I pay more attention to detail. I add some more weeds and grass with a pointed sable brush loaded with Prussian blue and Van Dyke brown, and I scribe additional weeds into the foreground with the sharpened end of a wooden brush handle. I use the pointed sable brush again to add the shadows cast by the boat's left siding and to add a hole to the bow with Prussian blue and Van Dyke brown. Then I sponge some dilute yellow ochre onto the sunlit side of the boat to soften the detail a bit.

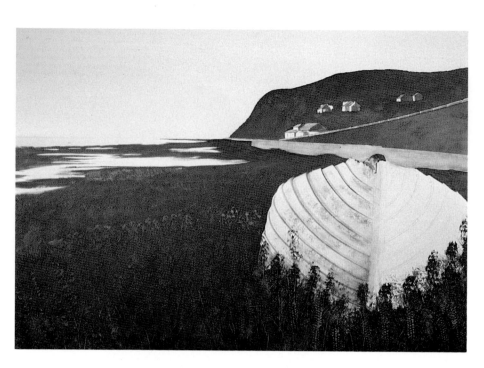

STEP FIVE. Using a ¾" chisel-edged brush, I block in the shadowed side of the boat with yellow ochre and Winsor blue. Then I use my pointed sable brush with a mixture of Prussian blue and Van Dyke brown to delineate the shadows created by the overlapping boards of the hull. After these lines have dried, I use the lift technique, with clear water in a ¾" chisel-edged brush, to highlight the siding on this darker side. These highlights suggest the reflected sunlight which this side of the boat receives. I add a clearly defined shadow to the beam of the boat with a mixture of Prussian blue and Van Dyke brown in a ¾" chisel-edged brush.

To achieve the warm afternoon glow, I apply more burnt sienna to the foreground with the stiff-bristle-brush technique, and I add more yellow ochre to the tidal pool. But now the tidal pool appears too light in comparison with the surrounding area, and so I add a second wash of cerulean blue.

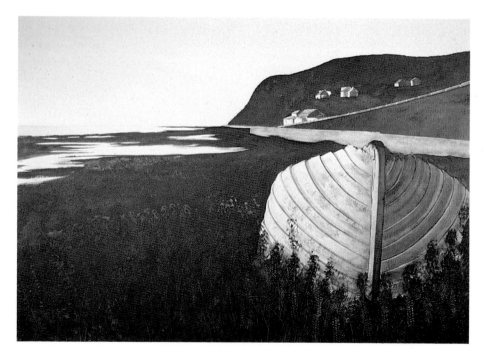

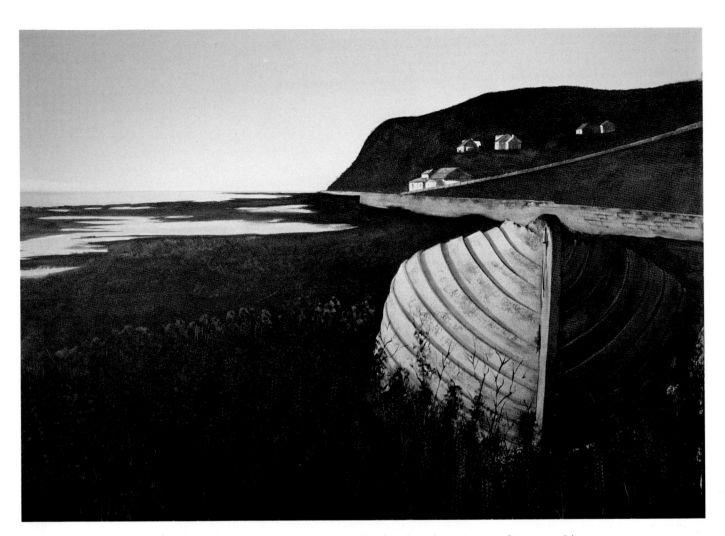

FINISHED PAINTING. I use a pointed sable brush with a mixture of Prussian blue and Van Dyke brown to add even more detailing to the foreground grass and weeds. I deepen the shadowed side of the boat with the same colors, but in a much more dilute mixture. The same mixture is used to strengthen the shadows on the sunlit side of the boat. I add detail to the seawall with a ¾" chisel-edged brush loaded with a mixture of burnt sienna and burnt umber. I then use the same size brush with a very light wash of Winsor blue to strengthen the tone of the seawater and tidal pools. Finally, I wash a very dilute mixture of burnt sienna and cerulean blue into the sky area, again using a ¾" chisel-edged brush. This final touch helps evoke the soft, somber mood of the setting sun and contrasts nicely with the golden hue of the seascape and hillside.

COTTON ROW

I have always been fascinated by building facades. Their shapes and forms—especially on older buildings—create abstract patterns which provide the balance between abstraction and realism that I look for when choosing a subject to paint. The old buildings here, in the riverfront cotton-row district of Memphis, are good examples of the type of architecture that I enjoy painting. There is a dignity of character here, a dignity that grows as the buildings age and suffer years of use. I am fascinated by the sharp contrast between the timeless vitality of the landscape and the desolate decay of these urban structures, and I love them both equally as subjects for my art.

Cotton Row will be done on Strathmore Hi Plate Illustration Board, 30″ × 20″ (76 × 50 cm). My palette will consist of Winsor blue, Davy's gray, Van Dyke brown, Prussian blue, burnt sienna, olive green, ultramarine blue, cerulean blue, raw umber, raw sienna, and cadmium red.

STEP ONE. I begin with a rather detailed sketch, using a soft 4B pencil because I want parts of the drawing to remain visible beneath color. I place masking tape over the upper windows as a resist, and then I paint the silhouetted side of a building to the right of the board, using a heavy mixture of Prussian blue and Van Dyke brown in a ¾″ (19 mm) chisel-edged brush. I begin with this area because I want to establish the darkest dark of the painting.

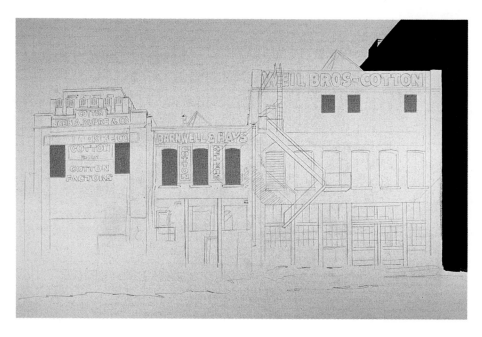

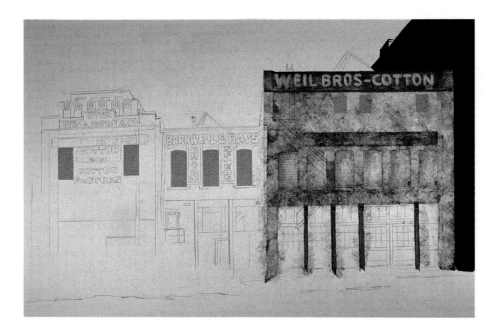

STEP TWO. I use a cadmium red, burnt sienna, and ultramarine blue mixture in a ¾" chisel-edged brush to block in the facade on the right. While the area is still wet, I roll a rubber roller over it several times to create a distinct pattern and texture suggestive of weathering. After the pigment has dried, I paint in two bands of ultramarine blue with a ¾" chisel-edged brush. The top band will serve as a background color, and the lower band will serve as an undertone for the lettering I will do. I also darken the upright areas between the doors with the same mixture. I then use a clean pointed sable brush dipped in water to lift out the lettering from the upper portion of the facade. Because I want the lettering below to be more subdued, I paint it in over the ultramarine undertone, using a pointed sable brush loaded with a mixture of Prussian blue and Van Dyke brown.

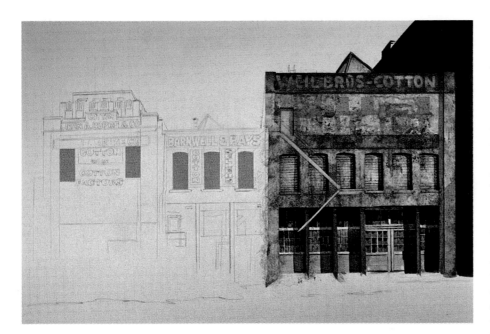

STEP THREE. Now I am ready to add detail and shadow to the structure. I begin by underpainting the windows of the loading doors with a dilute Winsor blue in a pointed sable brush. Then I use pure Davy's gray to block in the loading doors themselves. I pick up a concentrated mixture of Prussian blue and Van Dyke brown in a pointed sable brush and paint in the darkest shadow areas above the doors. Now I dilute the mixture and use the same brush to paint transparent shadows over the loading doors and boarded windows above them. With the same mixture and brush, I paint in further details— adding horizontal lines to the boarded windows and a cast shadow to the right of the building and creating broken glass areas in the loading-door windows. Now I add the skylight using a ¾" chisel-edged brush, first loading it with a dilute Davy's gray and then picking up a mixture of Prussian blue and Van Dyke brown for the shadows. Next I carefully lift the area of the fire escape by dipping a pointed sable brush in clear water and slowly wetting the area and then lifting the pigment with a dry paper towel.

STEP FOUR. I block in the center building with a mixture of burnt sienna and cadmium red and then blot the area with a wet paper towel. I use a pointed Kolinsky brush loaded with a mixture of Van Dyke brown and Prussian blue to add detail and shadows to the door area. I also paint in the dark windows with this mixture. Then I dilute the mixture to create the more transparent shadows. I want to include more detail in this middle area, and so I paint around the letters with a Kolinsky brush loaded with cadmium red and burnt sienna. This gives the middle structure a hard-edged strength. I complete this step by painting the skylight atop the structure with Davy's gray in a pointed sable brush. Then, picking up Prussian blue and Van Dyke brown with the same brush, I delineate the shadows.

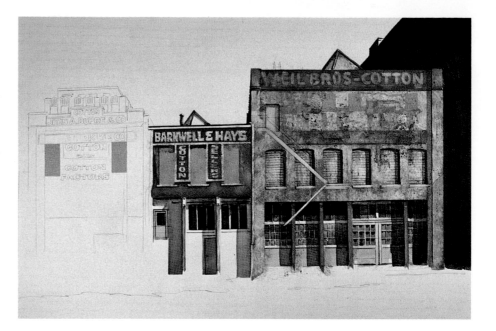

STEP FIVE. With a ¾″ chisel-edged brush loaded with a mixture of cadmium red, burnt sienna, and Van Dyke brown, I block in the building on the left side of the composition. Then I remove the masking tape from all three sets of windows, and I block them in with an underwash of Winsor blue, using a ¾″ chisel-edged brush. After this has dried, I use the same brush to add shadows to these windows with a mixture of Prussian blue and Van Dyke brown. Now I paint the superstructure above the building with a raw sienna overwash, and I detail the window areas with a mixture of Prussian blue and Van Dyke brown in a pointed sable brush.

I carefully paint in the tire escape on the right-hand building with a pointed sable brush and a concentrated mixture of cadmium red and raw sienna. Then I rinse the brush, pick up a mixture of Van Dyke brown and Prussian blue, and paint in the shadows cast by the fire escape. To complete this step, I return to the leftmost building and carefully lift out the lettering with a Kolinsky brush dipped in clear water and then blot that area with a dry paper towel.

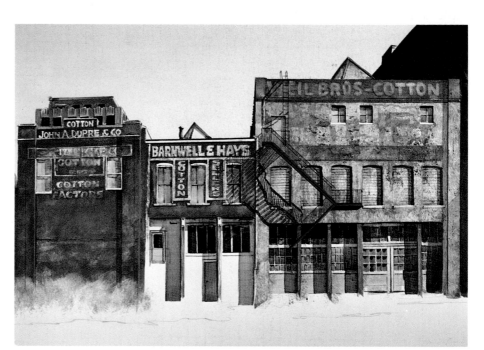

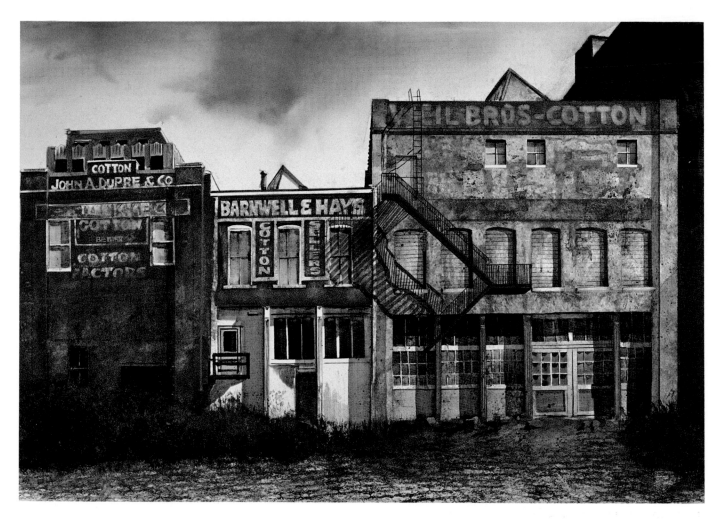

FINISHED PAINTING. I use surface color mixing to create the bushes and foliage in front of the buildings with a mixture of olive green, burnt sienna, Van Dyke brown, and Prussian blue. Then I mix raw umber, burnt sienna, and ultramarine blue and load it in a ¾" chisel-edged brush to block in the foreground pavement. While this area is still wet, I use a patterned sponge to create the texture of brick cobblestones. I save the sky area for last because I want to be sure it complements the overall mood of the painting. Now I wet the sky area and float in some Winsor blue from a sponge. Then I pick up some Davy's gray with the same sponge and float it in also, letting the two colors mingle freely. To complete the detail work, I add a door and window to the lower half of the leftmost building and a stairway to the middle building, with a mixture of burnt sienna and ultramarine blue in a pointed sable brush. Finally, I add a triangle of pure cerulean blue on the center door of the middle building to balance the prevailing warmth with the sky color and to complete the triangular motifs which occur throughout this composition.

TIPS

1. Beginners may find the hot-pressed surface so slick that they have difficulty controlling the paint. If you are having such difficulties, try swabbing the surface of the board with a sponge dipped in hot water. This will remove some of the sizing and cause the fibers to rise slightly. This "tooth" will help you control the flow of the paint after you apply it to the board.

2. Drying the board under a hair dryer or heat lamp can help save the nuances of dripped color. If you allow the board to dry more slowly, you will find that the paint spreads and flattens, blending into a more consistent hue.

3. It is most important to let the paint and board dry completely before you try to remove masking tape which you have used as a resist. If you try to remove the tape from a wet or damp board, you will tear the surface.

4. You can create highlights by using a plastic eraser or other abrasive eraser—even an electric eraser—if you use it carefully and sparingly. This method gives you a more hard-edged highlight, whereas a lift with water in a brush gives a softer look. Of course, a dye or stain pigment requires a more abrasive eraser to remove it from the hot-pressed surface.

5. Try painting in a "no lighting condition." In other words, first paint the entire scene without any shadows and then lay the transparent shadows where you want them.

6. Learn to make single stroke movements on the hot-pressed surface rather then the short, small strokes you use on absorbent papers. If you go back over an area on the hot-pressed surface, you may lift out part of the wash underneath.

7. To avoid a hard edge on the horizon, wet the area with a spray mister or pull a wet brush across the horizon line. But do this only *one* time. If you go back over it, the color underneath will probably lift out.

8. Correcting mistakes is easy with the hot-pressed surface. You can wash out a complete area and then repaint it. You can even blend the reworked area into the rest of the painting without leaving a telltale line.

9. Try leaving your paints on the palette—exposed to the air. If you mist them daily with a spray mister, you will find that the paint has more stretch and seems more "elastic" than it would if you kept the paint covered. Be sure to mist them often, or they will dry out completely.

10. Use a razor blade or knife to sharpen the ends of a few of your wooden-handled brushes. These will make very useful tools for scribing into wet paint on a hot-pressed surface. Wood is better than plastic because it won't bruise the surface.

GALLERY

The following gallery presents some of my favorite paintings on hot-pressed surfaces. As I was reviewing and selecting them for this section, I wondered what I could possibly say about the group as a whole. As I continued the sorting process, however, I realized how consistent in outlook these paintings really are. Nearly all of them seem to look for signs of life, especially in the midst of desolation. They all attempt to extract the essence and beauty of simple things. Also, most of them deal with man-made objects in a landscape—observing the contrast between the serene organic qualities of nature and the dynamic geometry of man's creations. I return to this theme again and again.

I constantly find myself attracted to the abstractions that underlie a good composition. My paintings are highly realistic, but they are not literal: they are interpretations, my efforts to uncover the abstract basis that makes this or that scene appealing. Although I believe that the design elements, the formal values, of a work of art should never overwhelm the subject matter, I do feel that the form plays an important part by carrying the content. In other words, the composition is the platform from which the subject makes its statement. Take away the composition and the subject—full of ideas and messages though it may be—has no physical structure from which to speak.

Composition is vital. It is like building a house: you start with a line—straight or curved, broken or solid—then you create shapes, and then reciprocal shapes, and these soon become form or mass. You build a relationship among these forms, you create proportion, and there you have it! Good composition is nothing more than the construction of a satisfying visual organization, one which will guide the viewer's eye through the painting and evoke an emotional response to the statement being expressed by the painting. This is my goal, and in achieving it I realize what all the preceding work is about.

CITYSCAPE, 30″ × 20″ (76 × 51 cm). This painting is the result of a commission I received from the Convention and Visitor's Bureau of Memphis. They wanted a painting that would be representative of Memphis, but otherwise they left me free to paint whatever I wished.

I spotted this scene while aboard a houseboat on the Mississippi River one day and asked the boat captain to hold the boat steady while I made some sketches and reference photographs. I felt that this view from the river, showing the skyline and new bridge, would be the most appropriate image of Memphis.

The painting required a more detailed drawing than usual because the bridge created such complex patterns. After completing the drawing, I floated in a mixture of Winsor blue and Davy's gray for the sky. Then I used a ¾″ chisel-edged brush to begin blocking in the skyline with washes of ultramarine blue, Davy's gray, and burnt sienna. The details on the buildings were painted with a mixture of Prussian blue and Van Dyke brown. Then the trees on the shoreline were painted with a sponge loaded with olive green and burnt sienna. The water was painted with a ¾″ chisel-edged brush loaded with a mixture of ultramarine blue and burnt sienna, and shadow detailing added with a diluted mixture of Prussian blue and Van Dyke brown. Finally, the detail of the bridge was painted with a pointed sable brush loaded with a more concentrated mixture of Prussian blue and Van Dyke brown.

PIKE'S PEAKS, 30" × 20" (76 × 51 cm). This painting began as an on-location sketch during a workshop I conducted in Virginia. I was attracted to the masses and angles of this scene, and it was also the first example I had seen of twin silos atop a barn.

After completing a carefully drawn study, I floated in a sky of ultramarine blue and Davy's gray. I used the richer ultramarine blue instead of my usual Winsor blue because the structure itself appeared to have a blue cast to it, and I wanted to pull some of this richer blue down into the structure. Next, I painted the mass of the barn with Davy's gray, adding some burnt sienna to warm it up. I used a mixture of Prussian blue and Van Dyke brown for the shadows, and then I pulled some ultramarine blue into the roof area. I used a pointed sable brush to add details with the same mixture of Prussian blue and Van Dyke brown. Finally, I lifted out some highlights on the roof and allowed the sky itself to give the final complement of blue that the painting needed.

Above

VACANCY, 30″ × 20″ (76 × 51 cm). This is a desolate-looking scene — with empty boxes, a ragged bedsheet, and even an old Philco radio left behind. I wanted to create a bleak mood to add to this sense of abandonment. Yet, to allow the viewer an escape to a more pleasant scene, I created a bright landscape outside. I placed strong sunlight patterns on the floor that create contrasting abstract shapes, and by doing this I have built tension as well as allowed an escape from it.

First I made a preliminary drawing, and then I painted in the darkest darks using Prussian blue and Van Dyke brown. I worked up to the lighter areas, pulling in mixtures of burnt sienna and Winsor blue from time to time and lifting out the lightest spots with a sponge dipped in clear water. When I painted in the final details, I used burnt sienna and yellow ochre for the box and radio, and cerulean blue for the sheet draped over the large box by the window.

Right

THE COMMON PLACE, 20″ × 30″ (51 × 76 cm). A photographer friend told me about this one-room schoolhouse in the Appalachian region of Tennessee. When I visited it, I was struck by the beauty of the sunlight streaming in through the lone window and the interesting shadows that it created.

After sketching the scene, I blocked in the walls with a chisel-edged brush loaded with Prussian blue and Van Dyke brown, but I was careful to leave the window area unpainted. I used a mixture of burnt sienna and Prussian blue to paint in the back wall and the shelf, and then I used the same mixture to paint in the seats and floor. After I painted in the cast shadows with Prussian blue and Van Dyke brown, I lifted out the sunlight on the seats and floor with a chisel-edged brush and clear water. Finally, I painted the scene outside the window and added a Winsor blue sky.

Above

Above

FRONT PORCH, 30″ × 20″ (76 × 51 cm). When I spotted this abandoned house, I was immediately attracted to the three rocking chairs on the front porch. They had obviously seen years of use, and there was a peacefulness about the scene which I wanted to capture. I decided to focus my attention on the three rockers, but include some hedge and sky in the painting to create a contrast between nature and man's creations.

After completing a detailed drawing of the scene, I applied a wash of Davy's gray to all the areas of the painting that depict wood. I then blotted these areas with a wet paper towel to create texture. Also, I picked up varying amounts of burnt sienna and Winsor blue with the Davy's gray, to create alternating warm and cool wood tones. The windows were painted using Winsor blue as an underwash and Prussian blue with Van Dyke brown for shadow detail. The color was lifted from the rocking chairs using a pointed sable brush loaded with clear water, and then the area was blotted with a clean paper towel. Shadow detail was added to the rockers using a mixture of Winsor blue and burnt sienna, and the sky was floated in with a mixture of Winsor blue and Davy's gray and allowed to dry. Finally, the hedge was painted using a sponge loaded with olive green, burnt sienna, and ultramarine blue.

Right

THE BLUE DOOR, 20″ × 30″ (51 × 76 cm). This painting is an exercise in textures. Bricks, wood, corrugated metal, the cane-bottomed chair — all these textures combine to build interest.

After I completed a simple drawing of the scene, I laid in an underwash of Davy's gray on the wood areas. Then I used a chisel-edged brush to paint the bricks with a mixture of burnt sienna and cadmium red. Then I blotted this area for texture with a wet paper towel. The shadows beneath the bricks were done with Prussian blue and Van Dyke brown, which I also used for other final details. The metal areas are burnt sienna, and the door itself is cerulean blue. Notice that I kept the area beside the door very dark to contrast with the light gleaming across the porch. I also exaggerated the perspective a bit and added to this stress by playing the cool blue of the door against the warm bricks.

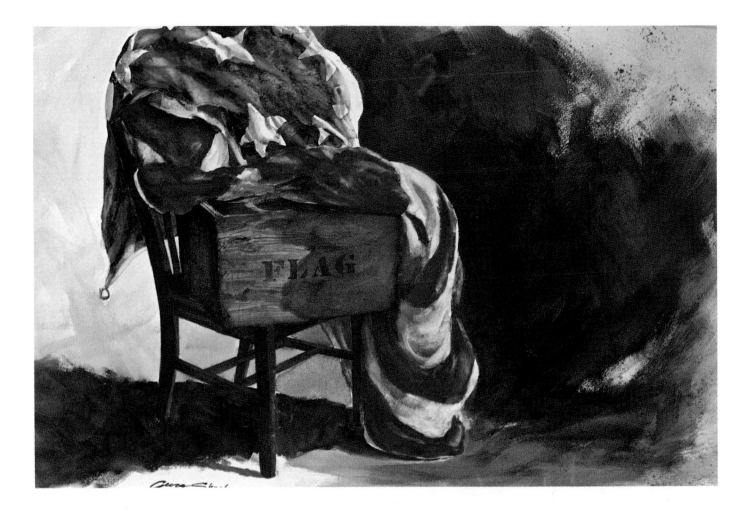

LATTICE WORK, 30″ × 40″ (76 × 102 cm). This house is in Jackson, Tennessee, and as I visited it one day I noticed how the sunlight created an abstract pattern on the wall, railing, and steps leading to the porch. The scene was so warm and inviting that I did some sketches on the spot. To keep my impressions fresh, I began this painting within a day or so. My preliminary drawing simplified things by leaving certain objects out, but the complexity of the remaining composition with its intense spots of sunlight still posed quite a challenge. I covered the patterns of spots with Maskoid and then blocked in the porch with Davy's gray. To get the pinkish glow of aged wood, I underpainted the walls with very diluted cadmium red. After some detailing and work in the shadow areas, I added the table and chair, and I created a checkered tablecloth with cadmium red and Winsor blue in a pointed sable brush. After washing in the sky with Winsor blue and Davy's gray, and creating the tree line and grass in the lower left, I removed the Maskoid from the sunlit spots. I then pulled a wet brush back and forth across these areas to get some color into them. This toned down the brilliant white of the board, yet preserved the intensity of these abstract patterns of sunlight.

UNCONQUERED, 30″ × 20″ (76 × 51 cm). This painting was done to commemorate the retirement of the 48-star American flag, and I wanted to emphasize the symbolic nature of this occurrence. So I left the background neutral and created this imaginary scene: a tired old flag is draped over an antique wooden chair; the flag has done its duty and is ready to be packed away in a decrepit wooden box.

I began this painting with a fairly detailed drawing, carefully indicating the folds of the fabric as well as the position of the stripes and stars. Then I used Prussian blue to paint the field around the stars, pulling in some Van Dyke brown for the darker shadows. I used cadmium red for the stripes and burnt sienna for the chair and storage box. After the paint was completely dry, I blocked in a neutral background of Prussian blue and Van Dyke brown. Then, to complete the composition, I created a cast shadow beneath the chair, using the same neutral mixture.

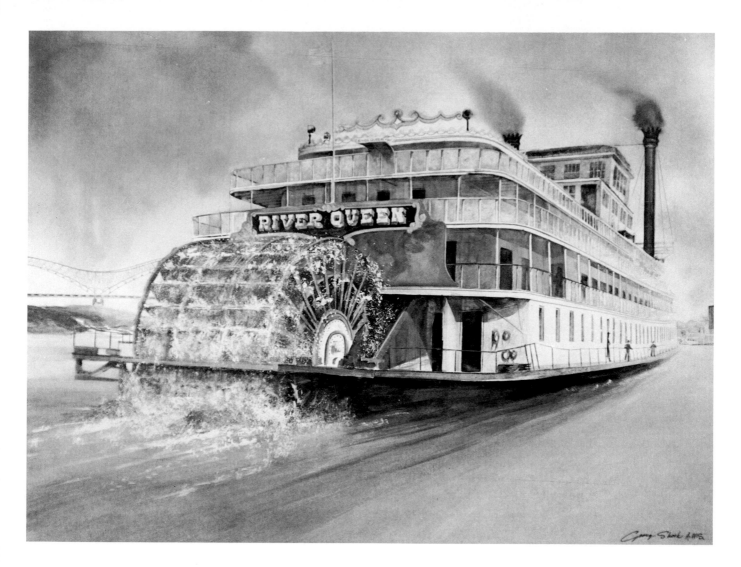

RIVER QUEEN, 40″ × 30″ (102 × 76 cm). The inspiration for this painting came from the *Delta Queen*, a paddle-wheeler that makes frequent stops at Memphis on its trips from Cincinnati to New Orleans. I took artistic license and added a Texas deck to the superstructure to create an image of a boat from another era.

After completing a very detailed drawing of the boat's intricate lines, I began the painting by washing in the sky with Davy's gray and Winsor blue. I then painted the surrounding area of the bridge and skyline using a very diluted wash of Prussian blue and Van Dyke brown. I created the water area by first wetting it with a sponge loaded with clear water. Then, using a brush loaded with Davy's gray and ultramarine blue, I painted in the bold, smooth strokes of the water area. Cadmium red medium, burnt sienna, and ultramarine blue were then used to paint the varying reflections. Next, the boat was painted using a brush loaded with Prussian blue and Van Dyke brown in different densities for both light and dark shadow detail. Cadmium red medium was used to paint the paddle wheel, with detailing added in Prussian blue and Van Dyke brown. The foamy white-water on the paddle wheel was painted using a sponge and opaque white. Final details were added with a pointed sable brush using Prussian blue and Van Dyke brown.

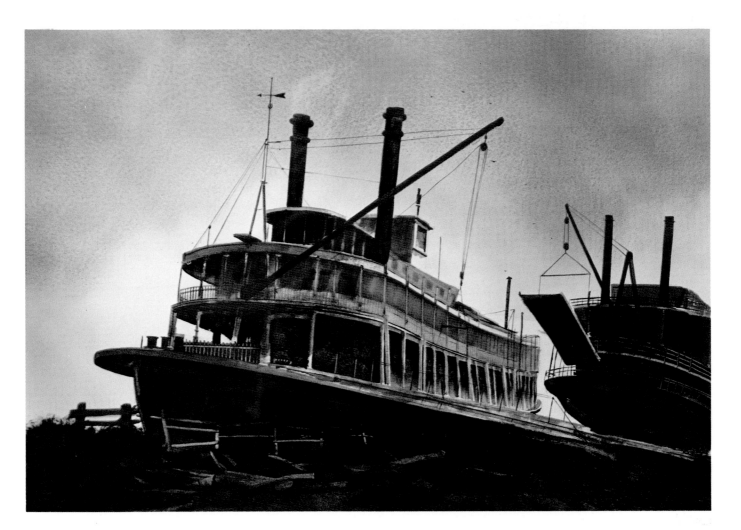

DRYDOCKED, 30" × 20" (76 × 51 cm). This painting was done for an exhibition entitled *The Mississippi River*. I had read somewhere how the old paddle-wheelers were pulled onto land by using skid logs and mules, in order to repair any damage done by logs drifting in the river. I wanted to depict what such dockings must have looked like.

Although I began with a very complex drawing, the final painting is practically monochromatic. First, I floated the sky in, and then I blocked in the darkest darks with Prussian blue and Van Dyke brown in a chisel-edged brush. I added detailing to the boats with burnt sienna and used this color freely in the foreground as well. Then, working while the paint was still wet, I used the wooden end of my brush to scribe some highlights into the scaffolding. For a last touch, I used a small chisel-edged brush and lifted some highlights from the side of the boat.

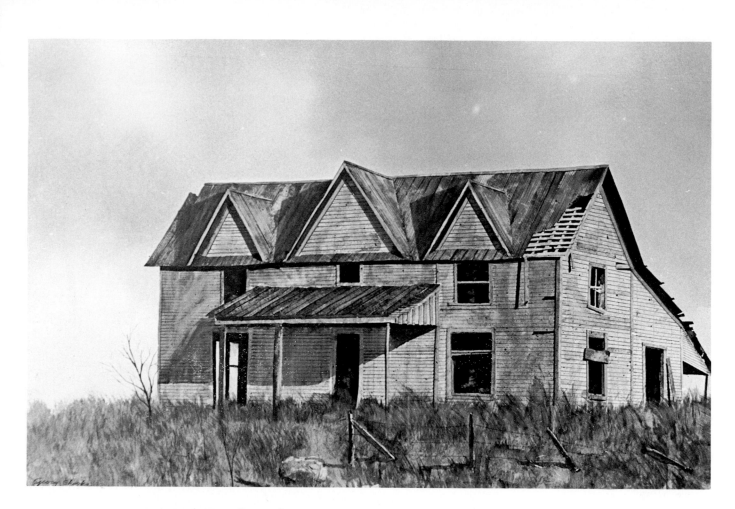

FIVE GABLES, 40″ × 30″ (102 × 76 cm). This old five-gabled house is typical of the small hillside farm and plantation homes that are fast disappearing from our landscape. This one was apparently abandoned because of an expressway that now cuts through the plantation to separate this house from the other buildings and storage areas. I wanted to pay homage to the strength of this fine old house as it continues to withstand the forces of nature. So, I altered the scene a little bit: although it was actually in deep shadow, I painted the structure as if it were proudly highlighted by bright sunshine!

I began with a fairly detailed drawing and used the wet-in-wet technique to float in a Winsor blue and Davy's gray sky. Next, I blocked in the wood of the house with Davy's gray, adding burnt sienna for warmth and Winsor blue for coolness. As usual, I blotted these areas frequently for texture, using a wet paper towel. I filled in the darkest shadow areas as well as the windows and doors with a pointed sable brush loaded with a mixture of Van Dyke brown and Prussian blue. The detail of the clapboard siding was actually done by the pencil-under-wash technique, and so you can see some of the pencil lines showing through the pigment. I mixed olive green, burnt sienna, and ultramarine blue, and I used the stiff-bristle-brush technique to create the grass in the foreground. I lifted out the fence and rock with the chiseled edge of a wet sable brush, and then I added detailing such as the shadow on the fence posts and shadow of the rock with a mixture of Winsor blue and burnt sienna.

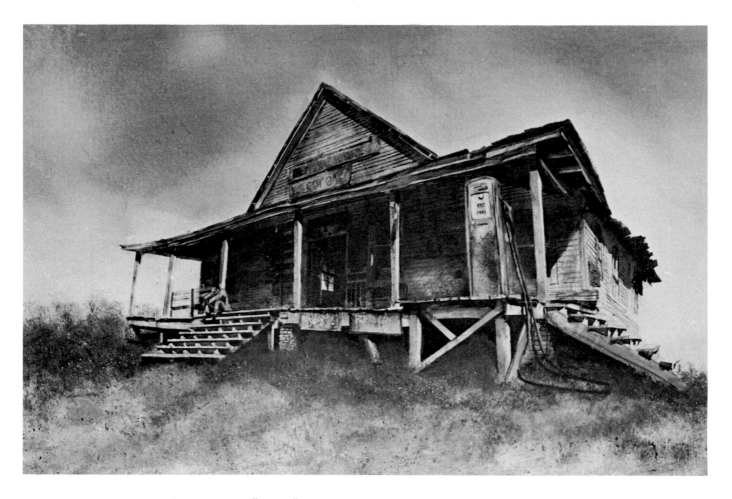

WE GOT GAS, 30" × 20" (76 × 51 cm). In my travels throughout the country conducting workshops, I am often told of places and scenes that I should visit and perhaps use as the subject of a painting. In this particular case, I was advised by a fellow artist to take a look at this service station/grocery store. I'm glad I did, for this is the kind of structure I like to paint. The lone person on the steps, the lone gas pump, the mood created by the light and shadow — all are aspects of a scene with mystery and character.

I began with a fairly simple drawing using a 2B pencil, and then I blocked in the sky with a wet sponge and floated in some billowy clouds of Davy's gray and Winsor blue. I used Davy's gray and burnt sienna to block in the structure, blotting for texture, and then I added detail with a pointed sable brush. After adding some shadow detail, I lifted out some highlights in the window area and on the front porch and steps, using a pointed sable brush dipped in clear water. I blocked in the grass using a chisel-edged brush and a mixture of burnt sienna and ultramarine blue. Then, rather than use the stiff-bristle-brush technique, I merely blotted the foreground to create texture and then added detail to the grass with a pointed sable brush loaded with Van Dyke brown and Prussian blue.

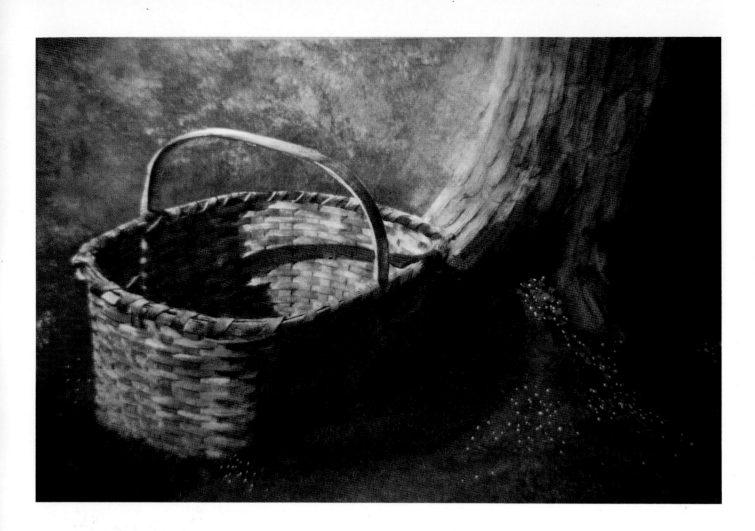

Above

YESTERDAY'S PICNIC, 30″ × 20″ (76 × 51 cm). I like to paint scenes which suggest a human presence, such as this forgotten picnic basket. Here I also had the opportunity to explore the underlying abstract design qualities contained in all good compositions.

This painting was accomplished using a fairly limited palette. I first made a detailed drawing of the basket and then covered the drawing with masking tape, using it as a resist. I created the grass areas using the stiff-bristle-brush technique with a mixture of olive green and burnt sienna, and I blocked in the tree trunk with Prussian blue and Van Dyke brown. Next, I removed the masking tape and painted the basket with burnt sienna and yellow ochre. I added shadows on the basket and grass using the same Prussian blue and Van Dyke brown mixture as before. Finally, I used the point of an X-acto knife to flick out pigment at the base of the tree and in the foreground—thus creating miniature wild flowers.

Right

PECANS, SORGHUM, AND BASKET, 20″ × 30″ (51 × 76 cm). This is a study of a basket which hangs in front of an old seed store on the Mississippi riverfront. Over the years this basket has held everything from cotton to corn, and I have always been intrigued by the interrelated shapes, textures, and colors surrounding it—the bottles and boxes in the background, the faded red on the post, and the way the sunlight illuminates the basket itself.

I made a fairly detailed drawing and then painted the darkest dark of the glass using a mixture of Prussian blue and Van Dyke brown. I then lifted out the shapes of the bottles on the shelves. I painted the basket with a mixture of yellow ochre and burnt sienna, while I created the shadows with a mixture of Prussian blue and Van Dyke brown. Finally, I painted the post with Davy's gray and added a smear of cadmium red to balance the color temperature of the cooler shadow areas.

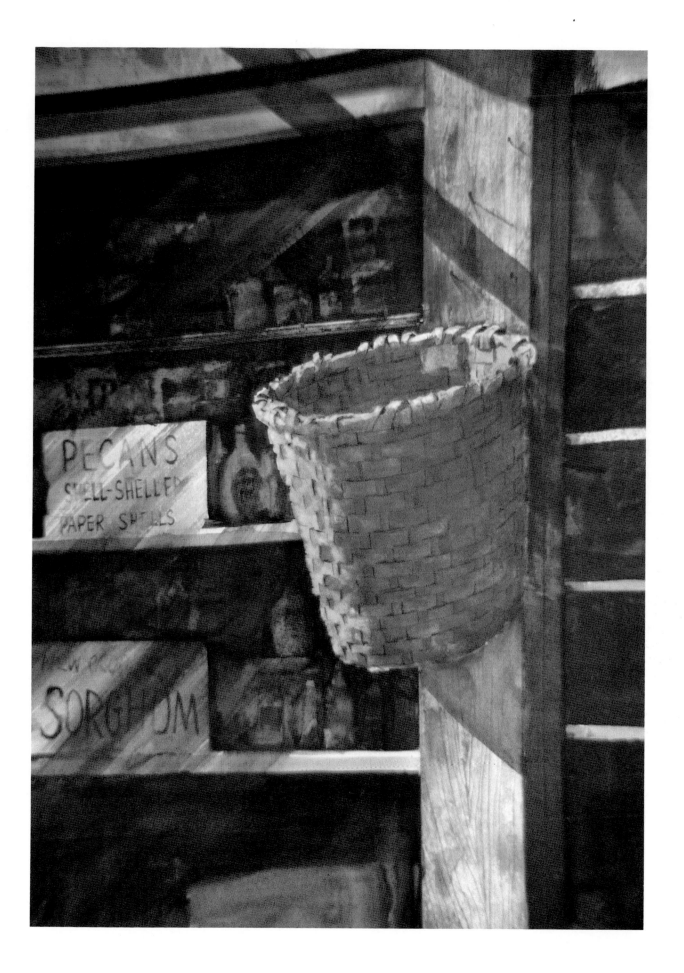

Above

COUNTRY GATE, 32″ × 26″ (81 × 66 cm). This is a very ordinary gate, but what intrigued me about it was its strength as an abstract composition. Its strong verticals, horizontals, and diagonals are beautifully counteracted by the delicately dappled shadows cast by the tree limb above.

I made a simple preliminary sketch and then wet the sky area and floated in a mixture of Davy's gray and Winsor blue. I used a ¾″ chisel-edged brush, picking up Davy's gray, burnt sienna, and Winsor blue to paint the wooden fence and gate. Wood grain and shadows were added with a pointed sable brush loaded with a mixture of Van Dyke brown and Prussian blue. I used the stiff-bristle-brush technique to create the texture of grass in the foreground, using olive green, burnt sienna, and ultramarine blue. I used a wet paper towel to blot in the texture needed to indicate the road leading to the gate. Finally, I created the shadows on the gate with a pointed sable brush loaded with a mixture of Van Dyke brown and Prussian blue.

Top Right

MURRAY'S GATE, 30″ × 20″ (76 × 51 cm). During a trip to Massachusetts, an artist friend of mine showed me a scene that inspired one of his paintings—which I liked so much that I decided to try my own interpretation of the same scene. However, I created a different mood by adding some evergreens and a trash can with a blue jacket draped over it.

Another interesting point is that I first painted the grassy area as though no gate existed. After the paint dried, I lifted out the gate by wetting the surface with a chisel-edged brush and blotting the area back to pure white. I added detail to the white gate with a chisel-edged brush loaded with Prussian blue and Van Dyke brown.

Right

CATTLE GAP, 30″ × 20″ (76 × 51 cm). Cattle gaps are seen throughout the rural South and are clever devices. Because cows won't walk across a bridge if they can see through it, a row of planks spaced slightly apart above the ground is as good as a gate for keeping cattle from straying. The dramatic play of light and shadow over this familiar scene interested me, and I used a heavily pigmented, almost opaque mixture of Prussian blue and Van Dyke brown to paint the backlighted silhouettes of the trees and fence. The shadows are a slightly lighter tone of the same mixture. The highlighted side of the cattle gap is Davy's gray and burnt sienna. I used the sponge technique to put in the distant trees and the stiff-bristle-brush technique for the grass. The colors in both of these steps were olive green, burnt sienna, and Winsor blue.

REFLECTION OF THE BIRDS, 40" × 30" (102 × 76 cm). This is a variation of one of my favorite subjects, reflections on glass. In this case, I incorporated the reflecting window into a larger scene that I created from several sketches. The piece of farm machinery was in another, nearby pasture when I sketched it, but I included it in the final drawing before I began the painting. On the building, I placed the window nearer to the end than it actually was and located the broken doors closer to the window. One of my reference photographs for this scene showed the birds above the tree line in a mirror-like reflection, and so I included that, too.

I began the painting by first masking the farm machinery with Maskoid, and then blocking in the barn with Davy's gray and burnt sienna, picking up a little Winsor blue to vary the color temperature. I blotted the side of the barn with a wet paper towel to give it the texture of weathered wood. To suggest the intense sunlight that day, I made all the shadows razor-sharp and very dark, using a mixture of Prussian blue and Van Dyke brown. After removing the Maskoid applied during the earlier stages, I painted the farm machinery with a mixture of burnt sienna, Winsor blue, and Van Dyke brown. I used Winsor blue as an underwash on the window and carefully painted the tree line with a mixture of burnt sienna, Van Dyke brown, and Prussian blue. The birds were done with a pointed sable brush loaded with pure Van Dyke brown.

REFLECTIONS, 33" × 25" (84 × 64 cm). I love the mystery of a vacant house, and when I pass one while driving, I always wonder what might have been left behind. This close-up view of such a house gave one answer, and it also posed some technical problems which I enjoyed working out. The lateral pattern of the clapboard siding and its distinct parallel shadows needed some countermovement, and so I added an electrical meter to create a strong vertical. This subject also offered the challenge of painting both the objects behind the glass and the reflections on the glass itself. Hi Plate board makes this easier than you might think, however, since any pigment can be lifted back out.

I began by painting the clapboard siding and then blotting for texture. After masking out the strips between the windows, I was ready to paint the windowpanes. First I laid in a wash of Winsor blue; then I painted the panes as if they were mirrors, reflecting what was behind me. I floated a mixture of Prussian blue and Van Dyke brown onto the panes with a sponge. I didn't cover them completely, but left some of the Winsor blue wash as reflections of the sky. I painted detailed reflections of the foliage in the upper panes, then blended that into the edge of the floated areas. Then I began the lifting process: I lifted out the evidence of the broken-down chair, lifted out the window on the other wall, lifted out the shadow on the floor, and so on. A pointed sable brush reestablished detail in the interior. The overall effect of these actions is a combination of both hard and soft reflections on the glass itself, plus a softer treatment of the interior of the room behind the window. To finish the painting, I added details on the wood surfaces and windowsill edges.

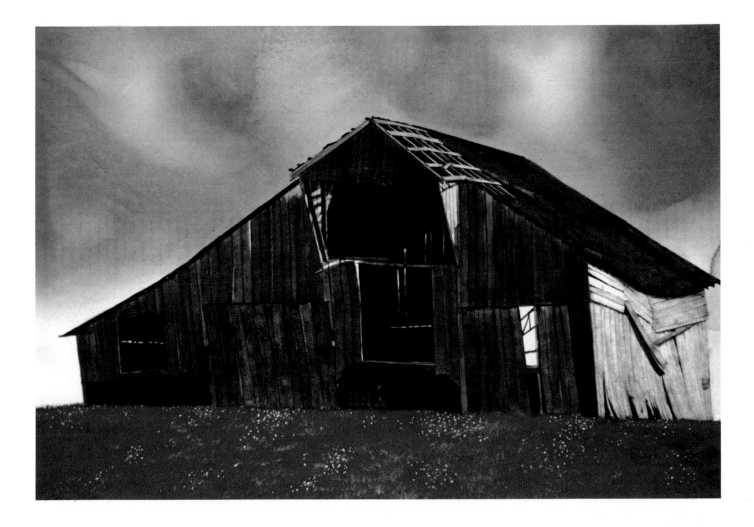

Top Left

ALL THE PAST SUMMERS, 30″ × 20″ (76 × 51 cm). I often like to play with a single scene, manipulating the design elements in various ways to see how many different kinds of paintings I can get from it. Here I wanted to create a strong interplay of abstract shapes, and so I created the overlapping planes of the rolling hills and positioned the fence and barn strategically on the near hill.

First, I made a simple drawing, and I covered the fence with strips of masking tape. Then I floated in a sky of Davy's gray and Winsor blue. Next, I blocked in the barn with Davy's gray, adding detail with burnt sienna. The shadows were added with Prussian blue and Van Dyke brown, and the grass was created with burnt sienna, olive green, and yellow ochre, by using the stiff-bristle-brush technique. After the paint in this area had dried, I removed the tape resist from the fence and added the shadow with Prussian blue and Van Dyke brown.

Left

OLE GLORY, 30″ × 20″ (76 × 51 cm). I happened upon this barn while painting on location in eastern Tennessee. Someone had created a very incongruous and amusing sight by painting the state flag on the side of the barn!

I made a detailed drawing of the barn and then floated in a Davy's gray and Winsor blue sky. I blocked in the structure with Davy's gray, using burnt sienna for the roof area. To create the flag itself, I used cadmium red and Winsor blue. I added detail to the barn with Prussian blue and Van Dyke brown. Then I wiped out the areas below it with a sponge and used the blue and brown colors again to create the eroded bank.

Above

AN APRIL MORNING, 40″ × 30″ (102 × 76 cm). I found this barn early one spring morning in Kentucky. With the white flowers in the foreground adding an extra charm to what was already a very satisfying scene, I decided to paint it.

I completed a detailed drawing of the structure first. Next, I floated in a Davy's gray and Winsor blue sky. I blocked in the barn with Davy's gray and added detail with burnt sienna. Then, using Winsor blue and burnt sienna, I painted the roof and used Prussian blue and Van Dyke brown for the shadow areas. I painted the grass with olive green and yellow ochre, and, after letting that area dry, I created the flowers by flicking away specks of pigment with an X-acto knife.

135

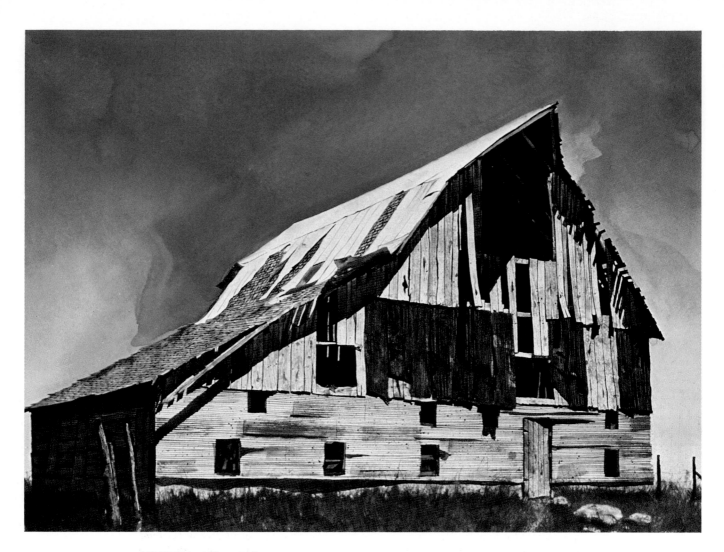

NEW TIN, 40" × 30" (102 × 76 cm). This painting holds a special significance for me, perhaps because it opened the way for my acceptance into the American Watercolor Society. Or perhaps it is because I still remember the impact this barn made on me when I first saw it near Springfield, Missouri. It was majestic, dramatic — its peaked gable a soaring inspiration. I made several preliminary sketches to get the composition and balance of shapes that would best show the magnificent character of this structure.

When I returned home, I began painting at once. First, I created a turbulent sky of Winsor blue and Davy's gray with the wet-in-wet technique. Then I blocked in the structure itself with Davy's gray and a little burnt sienna and Winsor blue to capture the contrasting tones of the wood. I blotted frequently for texture and lifted out the rocks and posts from the grass that I had created with the stiff-bristle-brush technique. I diluted a mixture of Prussian blue and Van Dyke brown to paint the transparent shadows cast by the roof and used a more concentrated mixture of the same colors to paint the deeper shadows and windows of the barn. I spattered dark colors onto the lower part of the building to enhance the aged effect and created the roof by lightly washing Davy's gray and burnt sienna over the detailed pencil drawing. I left the upper portions of the roof unpainted to designate the shiny new tin, which stood in such marvelous contrast to the aged wood. All these operations were done with a ¾" or ½" chisel-edged brush. Finally, I switched to a pointed sable brush to add some precise details and shadows to the entire structure, and that pleasant task completed what has remained one of my favorite paintings.

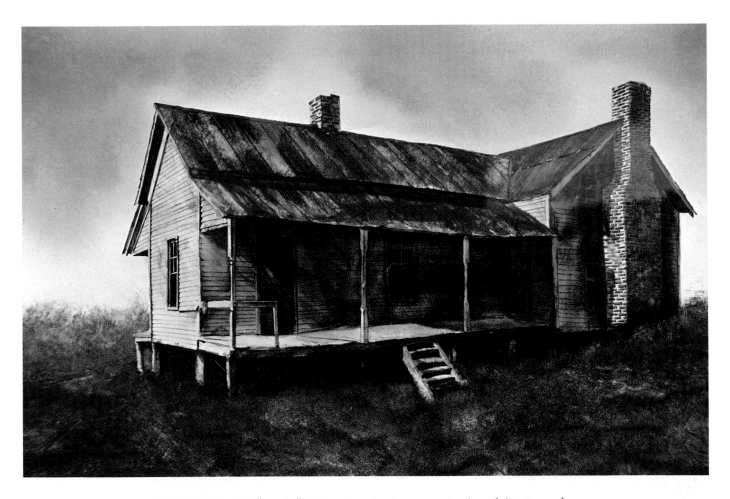

THE NEW ROOF, 30″ × 20″ (76 × 51 cm). The unusual color of this tin roof was designed by the owner of the house, an elderly man who actually painted it a rust color. I wanted to try to capture the way this strange-looking roof glowed in the sunlight.

The first step I took on this painting was to float in a Davy's gray and Winsor blue sky. Next, I blocked in the house with Davy's gray, and I painted the roof with burnt sienna, adding details of Winsor blue and ultramarine blue. For the detail and shadow areas of the structure itself, I used a Prussian blue and Van Dyke brown mixture. I created the grass last, mixing olive green and burnt sienna by the surface-color-mixing technique.

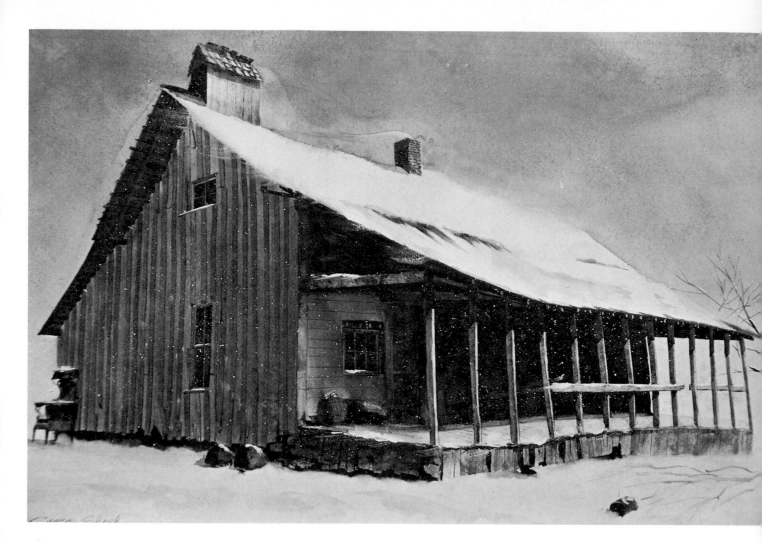

WINTER WINDS, 30" × 20" (76 × 51 cm). This is an old hunting lodge in Arkansas that still gets a lot of use from hunters who stay there during the quail, rabbit, and deer seasons. It is often snowy during these seasons, and that is how I wanted to paint the scene.

I first used Davy's gray to float in a sky, and then I used the same color to block in the structure. I created the effect of the clapboard siding using a chisel-edged brush and the colors Winsor blue and burnt sienna. I used the white of the board to represent the snow areas, although I did use an opaque white paint to indicate the falling snow. I also used opaque white along the left edge of the roof, first applying the paint to the roof and then pulling it off the roof line with my hand — thus creating the illusion of blown snow.

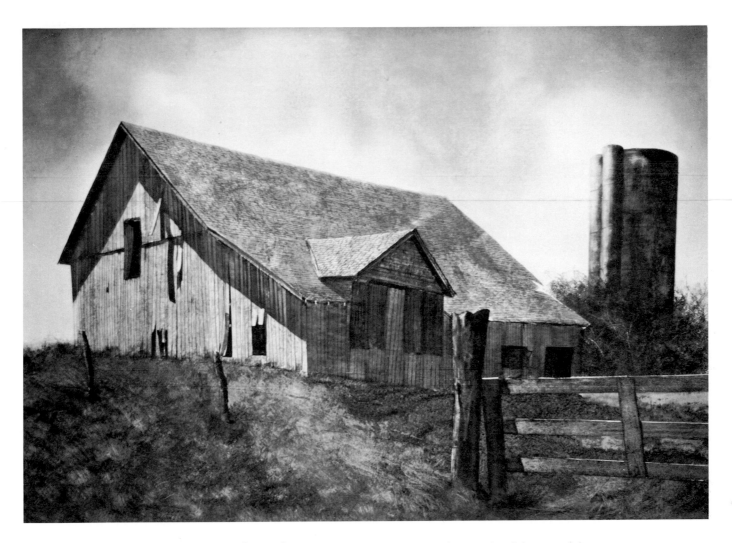

ANN'S BARN, 30″ × 20″ (76 × 51 cm). Here is a good example of the use of the pencil-under-wash technique as an integral part of the painting. Using a soft pencil, I first made a detailed drawing of the scene and even indicated the shingling on the barn roof. I then mopped Davy's gray into position. I blotted the barn with a damp paper towel and then used a chisel-edged brush to pull in some burnt sienna and Winsor blue. You can see that the pencil work still shows through the wash, giving the appearance of wood shingles on the roof.

To paint the trees, I used olive green and the sponge technique, and I added final details with Prussian blue and Van Dyke brown.

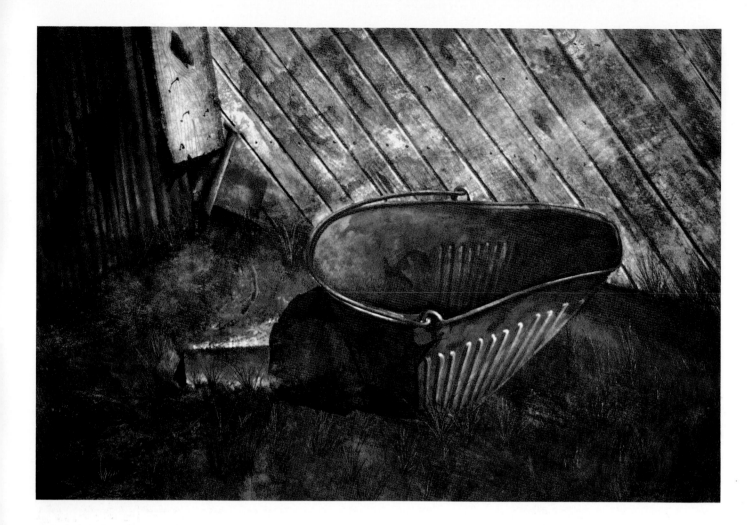

Above

THE SCUTTLE BUCKET, 30″ × 20″ (76 × 51 cm). I spotted this coal scuttle in a neighbor's yard, and, as I was designing the painting, I added the fence and corrugated metal. I was most interested in the strong design elements here — the interplay of angles, ovals, diagonals, and verticals all found within this realistic scene.

After completing a fairly detailed sketch, I painted the wooden wall and corrugated metal by variously using burnt sienna, Winsor blue, and Davy's gray. I blotted these areas often for texture and occasionally lifted out color to indicate a weathered area. To paint the grass, I first masked the scuttle area with masking tape and then used the stiff-bristle-brush technique to create a grasslike texture. Lastly, I removed the tape and painted the coal scuttle itself using burnt sienna, with Prussian blue and Van Dyke brown added for the shadows.

Top Right

PENNSYLVANIA FARM, 30″ × 20″ (76 × 51 cm). I found this inviting scene in Pennsylvania: four white farm buildings perched among the lush green hills of a rolling countryside. I knew that I had to paint it.

First I made a detailed drawing of the scene with a fairly soft pencil, and then I floated in a sky of Winsor blue and Davy's gray. I used a stiff-bristle brush to surface-mix the grass with olive green, burnt sienna, and ultramarine blue. Next, turning my attention to the buildings, I left the sunlit sides white while I painted the shadow sides with a mixture of burnt sienna and Prussian blue, occasionally adding Winsor blue for contrast. I used a chisel-edged brush loaded with clear water to lift out the area for the eroded bank, and then I painted in the bank with burnt sienna and Prussian blue. The final detail was the fence, which I painted in with a mixture of Prussian blue and Van Dyke brown in a chisel-edged brush.

Right

THE MILKING STALL, 30″ × 20″ (76 × 51 cm). Here is a structure that I spotted during a workshop in the Southwest. I tried to capture the contrast between the clear, brilliant sunlight and the shadows.

I blocked in the structure with pencil and then floated in a sky of Winsor blue and Davy's gray. I used the stiff-bristle-brush technique for the grass, and I painted the structure itself with a mixture of burnt sienna and Winsor blue over a Davy's gray underpainting. Finally, I used a mixture of Prussian blue and Van Dyke brown for the shadow areas.

140

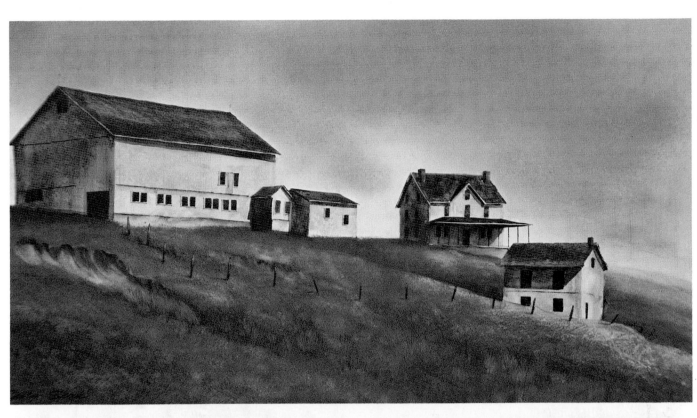

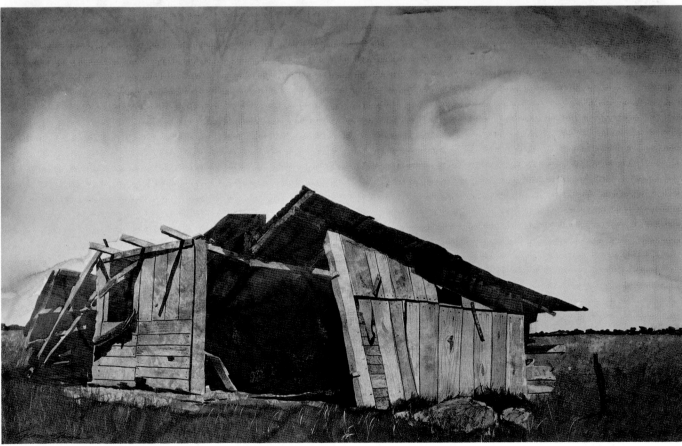

WINTER CHIMES, 26" × 18" (66 × 46 cm). This landmark building, located in an urban renewal area, was left standing after the entire neighborhood surrounding it had been destroyed by bulldozers. I wanted to record the desolate mood of this structure, but I actually intensified that mood by creating a subdued wintry scene.

I began with a detailed sketch, done with a 2B pencil, and then floated in a winter sky of pure Davy's gray. I blocked in the structure with a mixture of Davy's gray and burnt sienna and then pulled in some Winsor blue on the cool side to create a little color interplay. I used a pointed sable brush to add shadows and detail with Prussian blue and Van Dyke brown. I left the white of the board remaining to suggest snow on the roof and in the foreground.

INDEX

Georg Shook, nationally known artist, teacher, lecturer, and juror, was born in Charleston, Mississippi, and was graduated from the University of Florida and the Ringling Institute of Art in Sarasota, Florida. He has jurored state, national, and international competitions, and his paintings are in galleries, museums, and collections throughout the United States, Canada, Mexico, England, France, Germany, Japan, and Saudi Arabia. His work has been featured in such magazines as *American Artist*, *Today's Art*, *Northlight*, and *Art Voices South*, and in the book *Watercolor Painting Techniques* (Watson-Guptill). He is the author of *Painting Watercolors from Photographs*, also published by Watson-Guptill.

Shook has received more than 100 major national and international awards, including thirteen from the Tennessee Watercolor Society, ten from the Southern Watercolor Society, and four consecutive awards from the Watercolor USA show. Other awards are from the American Watercolor Society, the Rocky Mountain National Watermedia Exhibition, and the top award of the Rock City Barn National competition.

He is a member of the American, Southern, Tennessee, and Mid-Southern Watercolor Societies. He is past president and co-founder of the Southern, Tennessee, and Memphis Watercolor Societies, and he is co-founder and president of the Watercolor USA Honor Society.

Georg Shook lives, works, and paints in Memphis, and conducts workshops, demonstrations, and lectures throughout the United States, Canada, and Mexico.

Gary Witt was born in Wynne, Arkansas, and received his M.A. in humanities from Memphis State University. He is a photographer, a teacher of aesthetics at Memphis Academy of Arts, and a writer for various art publications. He is currently the owner/producer of Witt Productions, Inc., for which he writes and produces videos for the Arts and corporate communities.

Edited by Lydia Chen
Designed by Jay Anning
Set in 11-point Goudy Oldstyle